TOULOUSE-LAUTREC
THE NIGHTLIFE OF PARIS

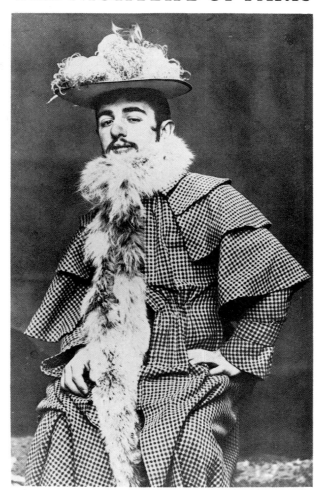

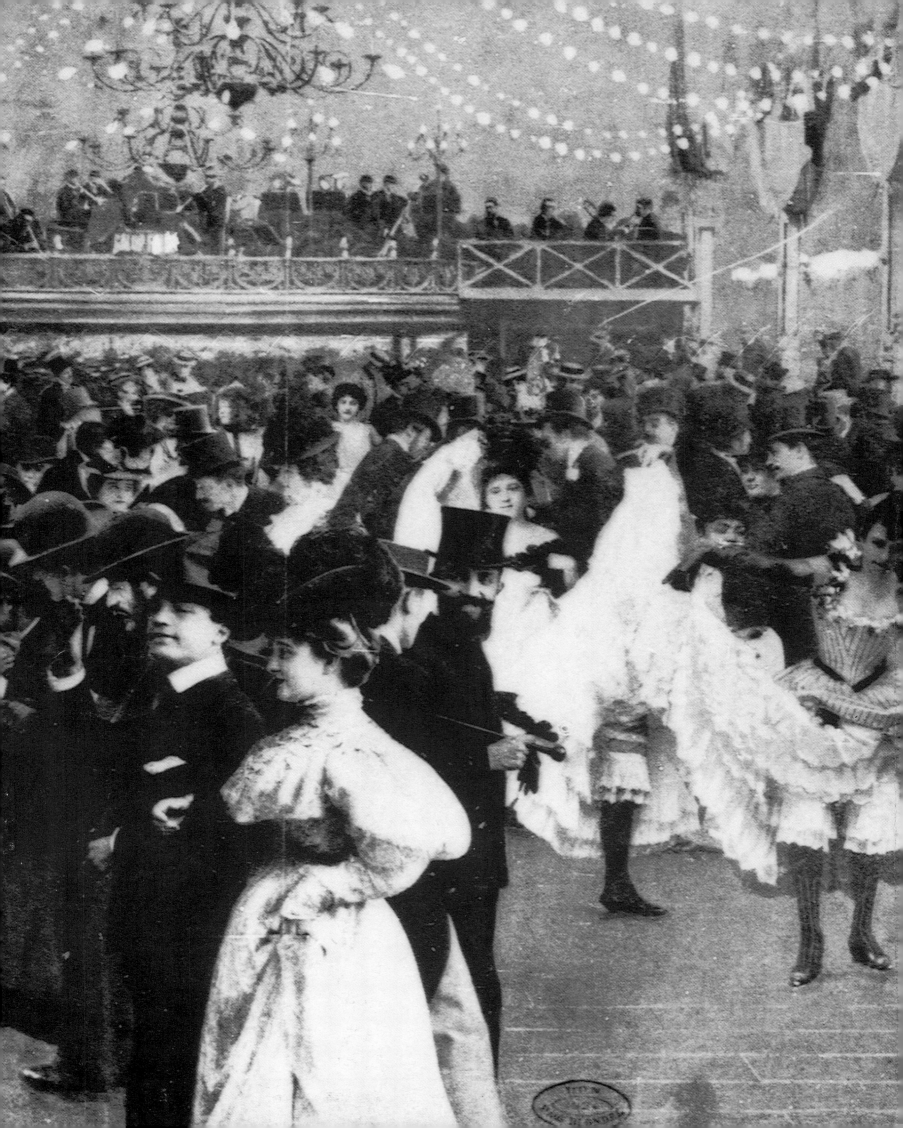

TOULOUSE-LAUTREC
THE NIGHTLIFE OF PARIS

PATRICK O'CONNOR

Phaidon Press Limited
140 Kensington Church Street
London W8 4BN

First published 1991
© Phaidon Press Limited 1991

A CIP catalogue record for this book is available from the British
Library

ISBN 0 7148 2688 X

Phototypeset by MS Filmsetting Limited, Frome, Somerset
Printed in Great Britain

(Endpapers) *A Gala Evening at
the Moulin Rouge* 1893,
lithograph, 29.5 × 47 cm
($11\frac{1}{2} \times 18\frac{1}{2}$ in)

(Half–title) Toulouse-Lautrec
wearing Jane Avril's coat, hat
and fur in about 1894

(Title page) The dance floor at
the Moulin Rouge
(Bibliothéque Nationale)

(Opposite) *Dr Gabriel Tapié de
Céleyran* 1894, oil on canvas,
110 × 56 cm ($43\frac{1}{4} \times 22$ in),
Albi, Musée Toulouse-Lautrec

In Memoriam

ARMOND STILES O'CONNOR

1913–1991

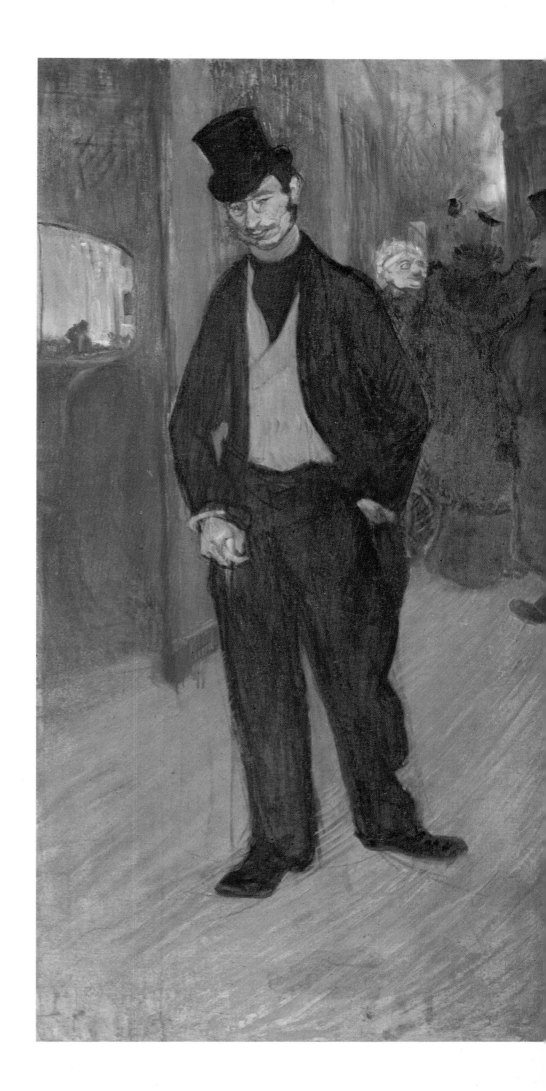

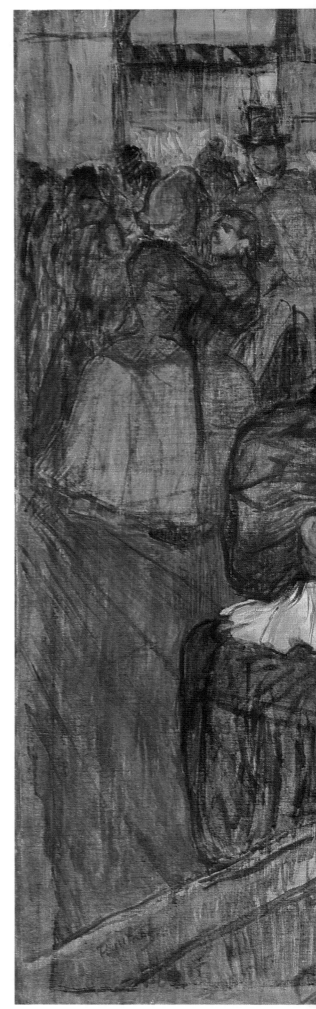

(Pages 6–7) *Moulin de la Galette* 1889, oil on canvas, 88.5 × 101.5 cm (34¾ × 40 in), The Art Institute of Chicago

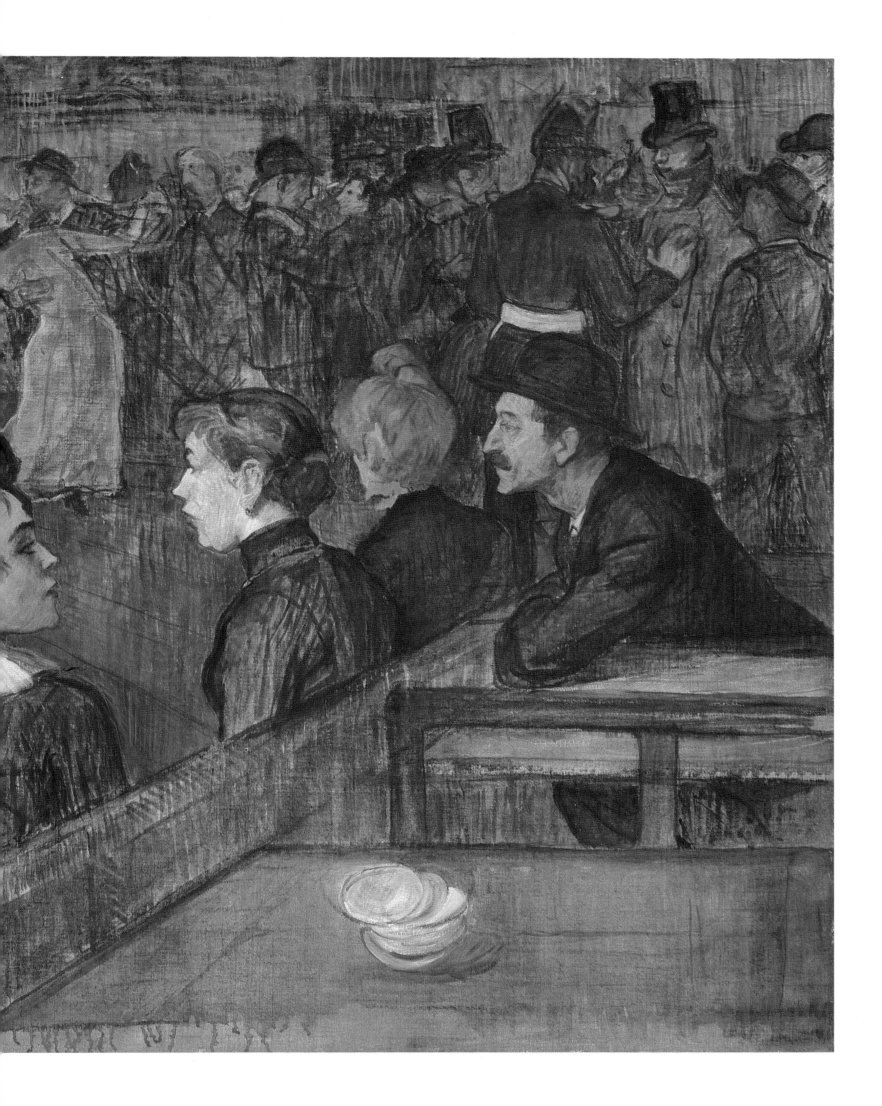

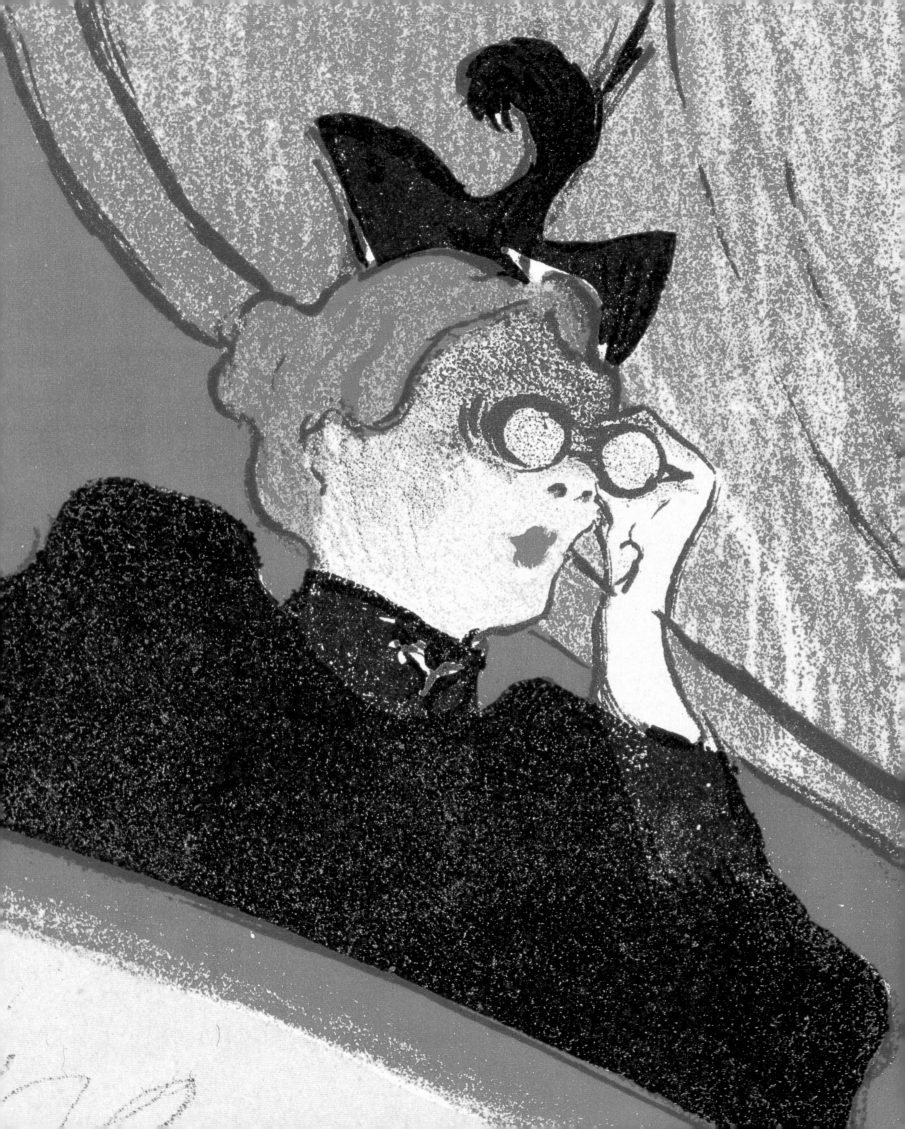

Toulouse-Lautrec: The Nightlife of Paris

One evening in February 1895, Alexandre Natanson, a well-to-do lawyer, gave a notorious party at his house at 60 Avenue du Bois de Boulogne. The reason for the party was to celebrate the completion of a set of murals painted for the reception rooms by Eduard Vuillard. Natanson had the malicious idea of engaging Henri de Toulouse-Lautrec to organise the catering. Lautrec drew an invitation, sent to 300 guests, summoning them at half past eight for 'American and other drinks'. Assisted by his friend Maxime Dethomas (Plate 3), who was two metres tall, the tiny Lautrec, his head shaved, dressed in white with a waistcoat cut from the stars and stripes of an American flag, worked doggedly behind the bar. The cocktails he mixed, all accompanied by dishes of highly spiced and salted food, were designed for their picturesque colour as much for their intoxicating power. Some drinks were meant to be taken at a single gulp, others in layers of colour, chartreuse, cointreau and curaçao, sipped through straws.

The elegant assembly of writers, painters, publishers and actors was reduced to a rabble of drunks, barely able to stand. Lautrec claimed with glee that he had served over two thousand drinks. Throughout the evening he remained sober.

Lautrec hardly needed such fuel for his view of Paris nightlife. The sight of others drunk, like seeing a familiar face suddenly reflected in a fairground mirror, is analogous with much of Lautrec's work. When one looks at his portraits and caricatures of the celebrated and infamous personalities whose fame his work has perpetuated for nearly a century, and compares them with the work of his contemporaries or with photographs, Lautrec's vision seems like that of a merciless voyeur. He combined a haughty disdain, inherited from his eccentric, *ancien-régime* forbears, with the outcast's acceptance of every human foible. If, as Arthur Symons wrote of Lautrec's favourite subject, Yvette Guilbert

> And a chill shiver takes me as she sings
> The pity of unpitied human things

Lautrec drew those same unpitied faces without sentimentality or censure.

It would be too convenient to ascribe Lautrec's choice and treatment of subject to his own physical disability. Yet, his descent—as his family perceived it—into the nightlife of Paris would have been unlikely had he not suffered as a child the illnesses and accidents that left him crippled, dwarfed and cut off from the aristocratic, horsey world to which he still belonged by

habit and attitude. As a seven-year-old he had written to his grandmother, 'Although I don't mind it here in Paris', he preferred to be back in the countryside. There was a part of him that always retained that nostalgia for rural society, which he masked with his barbed wit as he spent his days in the studios and cafés, and his nights in the cabarets, theatres and brothels of that most deceptive of cities: Paris in the 1890s.

Henri de Toulouse-Lautrec was born in Albi on 24 November 1864. His parents were first cousins, his father Count Alphonse-Charles de Toulouse-Lautrec, his mother Adèle-Zoë Tapié de Céleyran; they had married on 9 May 1863, and were to have a second child, Richard, born in 1867, who died at the age of one. In his old age, Count Alphonse was full of remorse at what he termed 'the mental torture, the ceaseless blame for not having refrained'. He evidently blamed the illnesses that his son suffered, an 'inoffensive soul', on inbreeding. During his infancy, Lautrec was a sickly child; he was sent at the age of 12 for electric massage treatment to stimulate the growth of his legs. In 1878, he was referring to himself as 'Monsieur Cloche-Pied' (Mister Hopalong); two accidents in which he broke both his legs, stunted their growth, and although his upper body grew, his legs remained as they were at the age of 13. After his death, his father spoke for his son his regret at losing the 'elegant, active life of all healthy, sports-loving persons'.

It would be misleading to imagine that the country-estate milieu that the family knew, at the châteaux of Malromé, Le Bosc and Céleyran, was conventional. Alphonse was an eccentric individual with a passion for fancy dress—chainmail, Highland kilts, djellabahs—who passed on to his surviving son much of his raffish manner as well as an interest in draughtsmanship.

The Moulin Rouge: the sign declares 'Son Altesse l'Amour' ('His Highness Love')

It was a family friend, the deaf-mute painter René Princetau, famous for sporting paintings, who first taught Lautrec and once his irrevocable disabilities were established, it was to painting that he turned. It is a mark of the total indifference to conventional values, that there seems to have been no objection on the part of Lautrec's parents at his decision to pursue a career as a painter, and at the age of 17 he moved to Paris, with his mother, and entered the studio of the academic painter Léon Bonnat, off the Avenue de Clichy in Montmartre. Although outwardly Bohemian, most of Lautrec's fellow students came from well-off families and, even if they did not like Lautrec return to the tranquil atmosphere of a house in the Faubourg Saint Honoré, they were nothing like the other young people who lived and worked in that rural Montmartre of windmills and dairies that, within the next decade, was to be replaced by one of the most durable and lucrative tourist-traps in modern Europe, the legend of which Lautrec helped to fashion.

An evening in Paris in the 1880s and 90s, when Lautrec made this nightlife the main focus of his work, might take several surprising turns. From the elaborate preparations of the woman of fashion's toilette, to the smoky

atmosphere of a bustling café, those fortunate enough to attend a ball at the Opéra would make an almost comic contrast with the habitués of popular dance-halls like the Moulin de la Galette (pages 6–7) or the more commercialised Moulin Rouge. The formality of the theatre, whether some avant-garde production by Antoine, or the traditionalism of the Comédie Française, would similarly have drawn different types of spectators than tuneful operettas like Hervé's *Chilpéric*, which so delighted Lautrec. The acrobatics of the circus clowns and riders was as skilled as the razor-sharp diction of the great cabaret stars, capable of silencing a hall without the inhibition of a microphone (Plate 17). The bistrot, the elegant private supper-rooms, the late-night bars where performers and artists met on mutual territory attracted his eye as well as his private world, behind the drawn curtains and soft-shades of the luxurious brothels. While the revellers continued in their dance and flirtations until dawn lit the sky, the early morning workers, the laundresses and market porters would already be on their feet (Plate 28 and page 80).

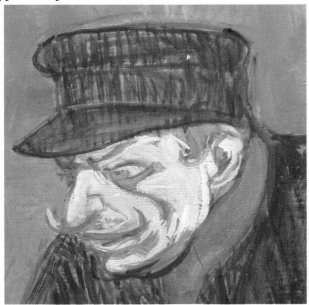

The Brothel laundry man, detail of Plate 27

It is a significant coincidence that the winter before Lautrec enrolled in Bonnat's class, and began his career in Montmartre, had also seen the opening of one of the most famous cabarets, with which Lautrec and his contemporaries would be forever associated, Le Chat Noir, at 84 Boulevard Rochechouart. Its proprietor, Rudolf Salis, was the first to recognise the complete possibilities of attracting a fashionable clientele to an apparently low-life atmosphere. In the grand tradition, rather than any obsequious politeness, his manner verged on the insulting. Famous primarily as a haunt of poets, the habitués of Le Chat Noir included former members of the Club des Hydropathes, founded by Emile Goudeau, among them Maurice Donnay, Jules Jouy and Alphonse Allais. Yvette Guilbert described the enthusiasm with which the crowd would sing old French country ballads: 'Passersby lingered in the street, lurking on the pavement in front of this closed door behind which one could hear such joy.' With his eye on a more lucrative public, the red-bearded Salis took larger premises in the rue de Laval (now rue Victor Massé); here the waiters were dressed as académiciens, with two-cornered hats and sword-belts; the doorman was dressed like a Swiss guard with a halberd, which he would pound on the boards to announce the arrival of any notable client. This passion for fancy dress seemed to dominate Lautrec's life; there are dozens of photographs of him and his contemporaries masquerading in costume, if not for a ball, just for the camera (Half-title).

What was to become of one of the most familiar outfits, a silhouette to rival that of Napoleon I in its fame, first appeared at Le Chat Noir. Aristide Bruant (Pl. 22 and pages 13 and 66), a wide-brimmed black felt hat topping his black velvet suit, the breeches tucked into high boots, a red muffler at his neck, a black cape and sturdy cudgel—for beating time or warding-off muggers, 'Dear old pal Bruant' as Lautrec called him, was the Bob Dylan of

his time, a singing poet who gave the Chat Noir its theme-song, which Lautrec and his cronies would howl with the rest of the crowd:

Je cherche fortune,
Autour du Chat Noir,
Au clair de la lune,
A Montmartre, le soir.

Like Yvette Guilbert and La Goulue, Bruant is remembered now mostly as one of Lautrec's favourite models; in the 1880s and 1890s he was one of the greatest stars of Paris, a composer, poet, publisher and impresario who brought to Paris, in Guilbert's words, 'the style of the old court of miracles, on the grands boulevards'. Bruant became one of the stars of Le Chat Noir and after its removal, he took over the room on Boulevard Rochechouart, renamed it Le Mirliton, and for ten years, from 1885 to 1895, he appeared there, declaiming his own ballads, on one hand berating the audience for its oafishness, on the other encouraging it to join in the choruses and drink up.

Bruant's voice was rather a dry-sounding baritone, not especially beautiful in timbre, but with an insinuating quality and the ability to catch the listener's attention. With his superb diction, Bruant lent the harsh verses of his tales of prostitutes, cut-throats and drunkards a distinction that has placed his work beside that of François Villon as a troubadour of the Paris night. Most of his songs are based on a simple four-bar motif, resolved on the repetition, easy to learn, impossible to forget. Standing on the tiny stage, directing the waiters to make customers shove up on the benches to let more people in, he would eventually lead the company in a drinking song that ended

Tous les clients sont des cochons!

Aristide Bruant, detail of Plate 22

Bruant published his own journal, *Le Mirliton*, with poetry and illustrations and he was one of the first to commission work from the young Lautrec. He drew covers for a number of Bruant's songs, perhaps the most famous a portrait of the heroine of his song *A Saint Lazare*, the lament of an imprisoned girl writing to her lover. When Bruant took his act onto the stages of the chic cabarets in the centre of Paris, Eldorado and Ambassadeurs, Lautrec produced his posters. Bruant's songs, though with their essentially Parisian *argot* they remain unknown outside France, have entered the folklore of our time. Schoolchildren sing *Le Chat Noir* and modern interpreters, among them Germaine Montero, Patachou and Greco keep his songs in the *chanson* repertoire.

Bruant, with his silhouette and statuesque manner, offered little variety to a portraitist. Rather than stillness, to capture movement, or to observe the chance moment, was Lautrec's greatest desire, and it was at another night spot L'Elysée-Montmartre, that he encountered first some of his other most engaging models. Since the 1840s, L'Elysée-Montmartre had attracted a popular clientele, at first from the butchers who worked in the local abattoirs, later a more mixed crowd. Its greatest success had come when the composer Olivier Métra was the bandleader. His sentimental waltzes and

Aristide Bruant (1851–1925),
his gentle expression belies
his aggressive reputation

polkas, *Les Roses, Les Faunes, Le Tour du Monde* and dozens of others had given the 1870s and 1880s their pace. His successor, Dufour is credited with the idea of reintroducing the high-kicking quadrille, which, renamed *le French Can-Can*, was to help not only Lautrec but all the Montmartre entertainment industry achieve lasting fame (pages 16 and 24). Jane Avril,

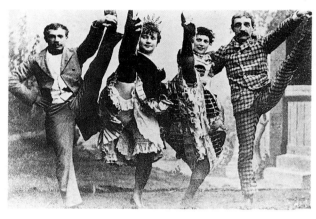

La Goulue, Grille d'Egout, Valentin and friend achieve perfect balance for the camera

(Plate 36) who began her career dancing at the Bal Bullier in Montparnasse, recalled that by the late 1880s the Elysée was already on the downward path. The manager, concerned at the slide into degeneracy, had engaged an individual known as 'Père la Pudeur' (Father Prude), to pass among the customers to check any untoward behaviour. 'All night he circled among the crowd, separating couples of the same sex, seeing that no one escaped without paying, and that no one's costume or behaviour offended his prudish eye'. Despite his reputation he must have been fairly broad-minded, judging by Lautrec's painting of the dance-floor which Bruant published on the cover of *Le Mirliton* in December 1886. Père la Pudeur, in the foreground, turns his back as the female dancers grip their ankles, their legs raised aloft revealing a cloud of white underwear and a length of black stocking. The audience, with Bruant in the background, applauds.

One of the dancers was Louise Weber, the Alsatian laundress soon to be notorious as 'La Goulue' (page 15). Lautrec painted her at least a dozen times. Her nickname—the glutton—came from her prodigious appetite for food and alcohol, alas the only one of her famous characteristics that she carried with her into the twentieth century. But, in the 1880s and 1890s she was the undisputed queen of Montmartre. Edmond Heuzé wrote of her, 'La Goulue was essentially a working-class girl, a girl of the pavements. She was really quite special. You only had to see her dance once to have this opinion confirmed.' A girl of the pavements, maybe, but Lautrec in his portraits invests La Goulue with an arrogant grandeur that seems to justify her success and her fame. Her trade-marks were her hair-style, a tight chignon hoisted into a top-knot, and her choice of provocative clothes, which included a pair of lace drawers with a heart embroidered on the seat, which she would display by way of a salute.

At the Elysée, the dancers were amateurs; La Goulue may have abandoned her metier as a laundress, but she was not yet a professional performer. Her partner was the long-legged shopkeeper turned landlord, Renaudin, who was known as Valentin-le-Désossé (Boneless Valentin). It was said that no one had ever seen him without his hat on, except when La Goulue would lift it with a swift kick from the toe of her satin dancing shoe. The contrast between the middle-aged bourgeois and the teenaged gutter-snipe was irresistible.

When the impresarios Oller and Zidler decided to cash in on the growing popularity of these authentic Montmartre song and dance venues, and open a place of entertainment to rival the Folies Bergère further down the hill, they engaged the best of the Elysée dancers to come and put on a floor-show at their purpose-built night-spot. When the Moulin Rouge opened in

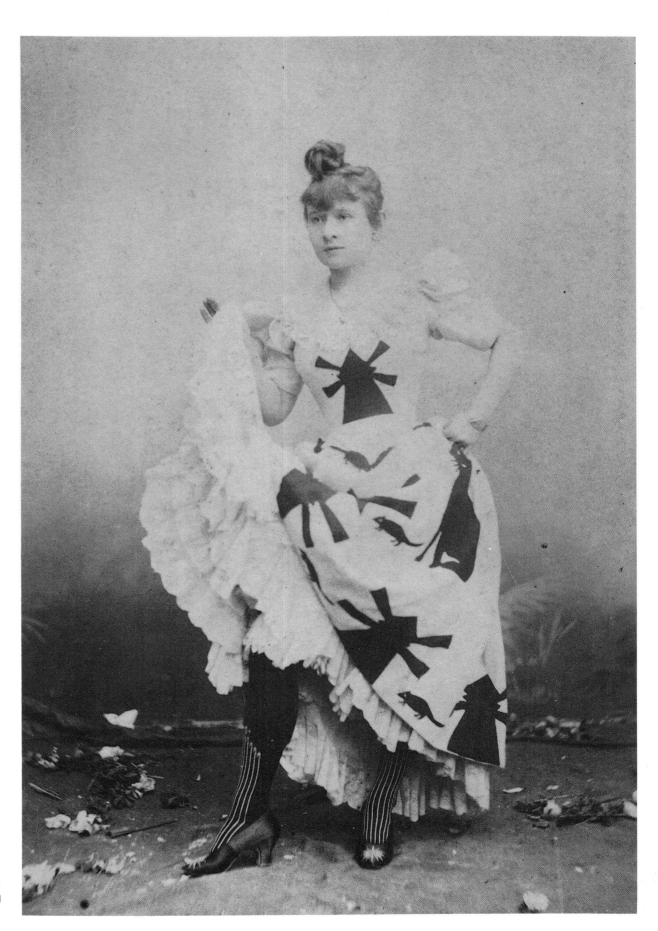

Louise Weber, 'La Goulue'
(1870–1929) at the height of
her fame. Windmills, cats and
rats decorate her gown

October 1889 it established the rage for Montmartre night-life and effectively marked the beginning of the end of the area as a place where artists and workers could live economically (Plate 7).

Oller and Zidler had opened the Moulin Rouge with the intention of attracting the crowds who were in Paris for the International exhibition of

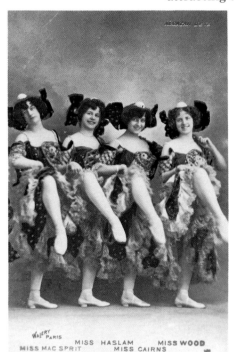

WALERY PARIS
MISS HASLAM MISS WOOD
MISS MAC SPRIT MISS CAIRNS

Many of the Paris music-halls featured high-stepping choruses

1889. The English impresario C. B. Cochran visited Paris for the first time, aged 20, the following year and recalled, 'It was unique as a place of entertainment, and I have never seen any place like it since. Ascending the hill to the Boulevard de Clichy, one's first sight of the Red Mill, with its four enormous revolving vanes painted a brilliant red and outlined by electric lights, was anticipated by the red glow which it threw to the sky. The actual mill was on top of the entrance to the dance hall. Passing through the lobby, I recall a long corridor with posters by Chéret and Lautrec on the walls, which led to the great ball-room.'

Chéret, the artist of whom Lautrec was to write, 'As for the posters, Chéret eliminated the black, it was wonderful. We put it back, it's not too bad,' had been commissioned to make the poster advertising the hall, which showed a typically rotund beauty of the time riding a donkey. 'As a diversion from dancing,' as Cochran recalled, 'the little ladies raced around the garden on little white donkeys—another excuse to display ruffles and legs,' (End papers). Once Lautrec had made the first of his large-scale paintings of the Moulin Rouge, Zidler ordered a new poster, Lautrec's first, and the work which made his name and remains one of the most familiar images of the iconography of Paris nightlife. It shows the spectators gathered around the main dance-floor, in the centre of which La Goulue is in the full frenzy of her dance, balancing on one high-heeled slipper, petticoats frothing as she twirls her right foot in mid-air. Valentin is silhouetted in the foreground. It was the custom of the establishment for men to retain their hats which 'added something to the unconventionality of the scene' (Title-page).

There were raised platforms on either side from which the spectators could watch the dance, and around the floor were tables at which drinks were served (Plate 6). 'Male customers were quickly invited to buy drinks by gaily dressed ladies, some of whom, it seemed to me in my twentieth year,' recalled Cochran, 'were very charming. They were gaily dressed in many colours and wore on their heads huge feathered and beflowered creations.'

Although Lautrec painted many portraits of men—stable lads and jockeys, colleagues, actors and boulevardiers (Plates 3 and 18), it is for his studies of women that his work is most prized and it is that ambiguous, analytic quite critical attitude that he seems to take to his female subjects that found its full outlet when he began to haunt the Moulin Rouge. As well as the dance hall, the establishment boasted the pleasure garden, which had its own bandstand and stage, to the side of which stood a huge papier-mâché elephant, a leftover from the 1889 exhibition, in the belly of which was a fair-booth in which extra entertainments took place.

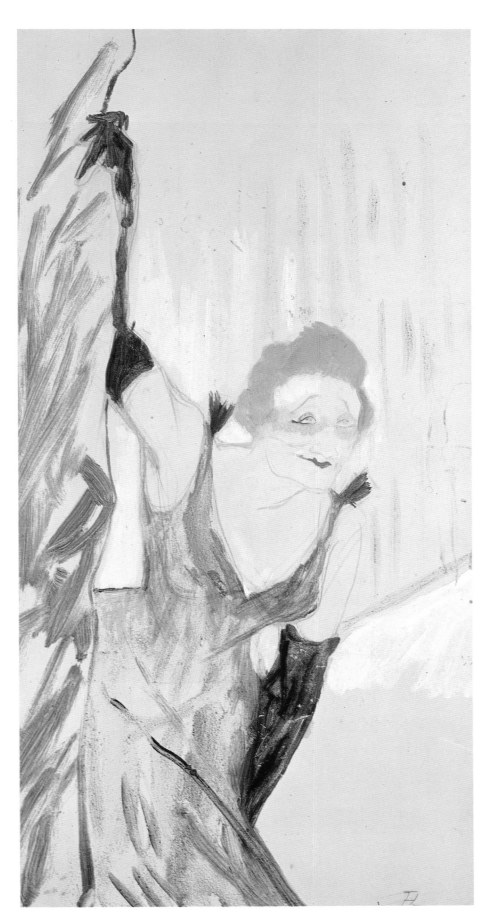

Yvette Guilbert greeting the public 1894, oil on card
48 × 28cm (19 × 11 in), Albi,
Musée Toulouse-Lautrec

Although the main attraction remained La Goulue and the other dancers, Grille d'Egout, Cha-U-Kao, Rayon d'Or and Lautrec's greatest friend among them, 'La Mélinite', Jane Avril, more and more people were drawn to come early to the café-concert performances that started at 8 o'clock, at which Yvette Guilbert sang her repertory.

Guilbert made no concessions in her act to conventional music-hall glamour (Plates 14 and 15, page 18). She wore no jewellery, just a simple evening gown and the long black gloves which, though she claimed them as an economy to save on laundry bills, were an essential element in her performance, the silhouette of her arms against the backdrop adding a shadow play to the narrative of her songs. She declaimed her chosen poems and couplets against arrangements of popular tunes: *La Pierreuse* by Jules Jouy, for instance is set to the 'Air du Pi-ouit' from Lecocq's *La Rousotte*, and *Madame Arthur* by Paul de Kock, so famous that a cabaret was named after it, uses the entre'acte from Donizetti's *La Fille du Régiment*. Success seemed slow to come to Guilbert but it was only a few weeks after her first appearance at the Moulin Rouge that she received the first press eulogy, by René Maizeroy in *Gil Blas*, a celebrity that was to last for 50 years. The management of the Divan

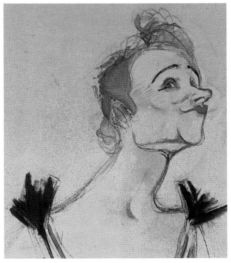

Yvette Guilbert, detail of Plate 14

Japonais, in the rue des Martyrs offered her 40 francs a night to appear in a late-night performance. 'Shall I ever forget those first glorious days of independence. Or the wild bursts of enthusiasm that filled the hall, the ceiling of which was so low that my head almost touched it! Or the crowds who used to leave the Moulin Rouge every evening at the same time as I did in order to go on to the Divan Japonais and hear some more of my songs.' Jehan Sarrazin, the manager-poet, passed among the audience selling packets of olives, the wrappings of which were printed with his own poems. Guilbert never permitted Lautrec to make the poster for which he drew a large-scale study (Plate 14), but she was astute enough to recognise that his dozens of drawings of her , which eventually resulted in two editions of lithographs, published in Paris and London, signed by painter and singer, would outlive all the other paintings and cartoons that her performances inspired.

It comes as something of a shock to see what a fresh-faced young woman Guilbert was in the 1890s. Her outraged, 'Petit monstre! Mais vous avez fait une horreur!', scrawled on the portrait on a ceramic plate he made, seems quite understandable (Plate 15). What he drew was the dramatic insight that Guilbert brought to each song. With no props, she created a miniature drama or comedy from each brief poem or song. Her old bag ladies, prostitutes, men on the scaffold, drunken debutantes or cynical men-about-town, all of whom she could characterise with her impressive range of vocal nuance, were achieved with what Shaw called the fanaticism which would kindle art 'to the whitest heart'. Siegmund Freud, with whom Guilbert enjoyed a long friendship, could only analyse her theory, that the secret of her success lay in the technique of setting aside her personality in order to replace it by the character she wished to present, by suggesting she drew on 'supressed desires', but was forced to admit it was a mystery why

Yvette Guilbert as she was on her visit to London in 1894

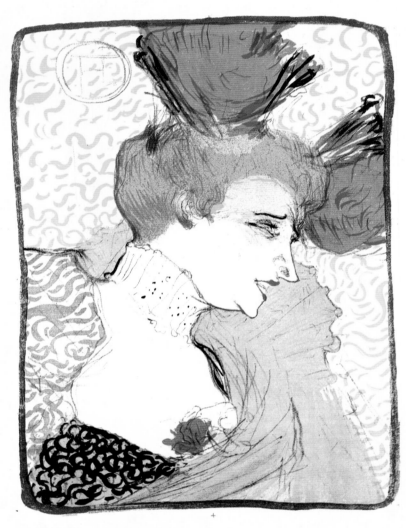

'we should shiver before *La Soularde* and answer "yes" with all our hearts to the question *Dites-moi si je suis belle?'*

Guilbert's singing technique was unclassical, but her voice was remarkable. Shaw also commented on her reliance on the middle and lower registers, and in her numerous recordings, made between the late 1890s and the time of her death in 1944, one can hear the dramatic thrust and subtle skill with which, within a few phrases, she could imitate the voices of a deserted girl, her lover and the priest in *La Delaissée*, or the drunken beggarwoman chased by children in *La Soularde*, with its almost oriental-seeming wail on the repetition of the title, rolling the 'R'. Max Beerbohm described her singing of Bérenger's *Ma Grand' Mère*, 'Always she obeys the rhythm of the music. All her acting is done within that limitation . . . how perfectly she differentiates the words of the girl from those of the old woman, yet with hardly a perceptible change of key. Something happens in her eyes, and we know that it is the girl speaking; and then again, in another instant, we see the old woman.' Lautrec portrayed her in a number of specific songs, including *La Soularde, Linger Longer Loo*, an Anglo-American parody, and Jean Richepin's *La Glu*, which one of her fiercest critics in America described as 'morbid, coarse and in beastly taste'.

Lautrec referred to Guilbert as 'the Diva' and after he met her in Nice and they discussed the idea of the poster that never was, he wrote, 'This is the greatest success I could have dreamed of—for she has already been depicted by the most famous people'. Lautrec had already drawn Guilbert on numerous occasions when he went to take luncheon with her at her apartment in the avenue de Villiers in the spring of 1894. In the first volume of her memoirs, *La Chanson de ma vie*, published in the 1920s, Guilbert wrote a lively description of this meeting, which began with her butler running to her and saying, 'Mademoiselle! oh! mademoiselle! Monsieur Donnay has arrived, with a funny little creature.' What did he mean, she asked, and he said that Lautrec looked like a puppet. Guilbert compared his head to that of one of the figures from the Guignol theatre, for once she was struck dumb, then she looked him in the eyes: 'Oh how beautiful they are, large, wide, full of warmth, surprisingly bright and full of light.' As she watched him, he removed his spectacles, aware that his eyes were the one part of his appearance that attracted people. Before she had time to worry overmuch about how to seat Lautrec at her dining table, he placed his hands on one of the large dining chairs, took a little leap and plonked his body beside the hostess. Although his chin was only a few inches above the table-cloth, or so she recalled, he ate heartily, making a slurping noise with the sauce rémoulade, and scandalising Yvette's mother with his conversation. Guilbert complained that he had yet to give her one of his drawings, and she said that if he didn't send her one she would come and fetch it. He burst out laughing, 'Do you know where you would most likely to find me?' She supposed at his studio? 'No,' said Lautrec, 'in a house of . . .' Yvette didn't need to have it spelled out for her. The subjects of so many of her songs were prostitutes, street-walkers, or camp-followers,

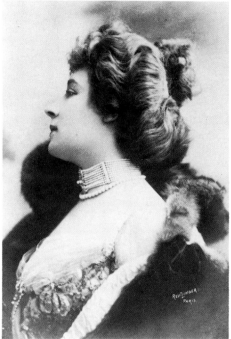

Marcelle Lender
(1862–1927), seen by
Lautrec and by the camera

21

young and old, like those of *Éros Vanné*, a song that Maurice Donnay, who was lunching with them, would write for her, and for which Lautrec drew the illustration when it was published. Two knowing-looking pavement lilies sit at the bar, while cupid, his leg in plaster, supported by a crutch, hobbles away.

Lautrec's influence quickly found its way on to smutty post-cards

But what of love, what of the heart, Yvette demanded? 'Oh, yes, love, love,' he replied. 'You can sing it in every key, Yvette, but my dear, hold your nose! If you were singing to us *Le Désir*, we would listen and be amused by the infinite variety of heartbeats, but love, my poor Yvette, love does not exist.'

In his twenties Lautrec had, indeed, moved from his mother's house and, taking a lease on one studio after another in and around Montmartre, had found beyond the entertainment in the cafés-concerts and theatres, an extraordinary life behind the closed doors of the brothels of Paris. In particular there was a house in the rue d'Amboise and another, perhaps the most elaborately equipped house of pleasure of its time, in the rue des Moulins (Plates 23 and 24). Rooms furnished with instruments of torture, others done up like scenes from the Arabian nights, and a bed that was supposed to have belonged to Marie Antoinette provided entertainment for anyone with enough cash to pay the price (page 76). Lautrec had his own room there and painted the girls at rest, their own love-affairs (Plate 26) and the boredom (Plate 25) and petty-mindedness, sometimes relieved by a trip to the theatre or the countryside that he would organise. For these girls, most of whose names are forgotten, only known by their nicknames like 'Elsa la Viennoise' or 'Madame Poupoule' Lautrec reserved his most observant characterisation. If anything, our attitude in the late twentieth century to the idea of prostitution is even more prudish than that of the Victorians. Why this should be remains a mystery, for the service provided by the oldest profession is a useful, even noble, calling, as Lautrec understood. He took the Madame of one of the brothels to the opera with him, and as a favour painted a series of panels, portraits of the girls surrounded by garlands of flowers, to decorate the salon in the rue d'Amboise. The girls called him 'Monsieur Henri' and took him into their confidence. The proprietress of one of the establishments speaking many years later to Francis Jourdain, remembered how he would tap with his walking stick along the parquet corridors, humming a snatch of some popular ballad such as the 'Chant du Départ' and his friend Maurice Joyant recalled how he would ask the girls to dance together, to the accompaniment of the mechanical piano. 'In their shifts and with their coloured dressing-gowns negligently draped about them, he would urge them to glide backwards and forwards, so that he might clearly observe their movements; then he would enthusiastically extol the poses they adopted, which he found evocative of Botticelli's *Primavera*'.

'Love doesn't exist', yet Lautrec did have sentimental adventures, with models and other artistically-minded young women he met in his round of the society of the avant-garde theatre, racecourses and salons. His attitude

remained on the defensive, and when the success of his pictures of Guilbert encouraged publishers to commission two other series of portraits of stage personalities, his caricatures of Sarah Bernhardt, Réjane, Jeanne Granier and the other great stars seem quite fierce. One of his projected subjects, never published and now lost, was a picture of the English music-hall performer Little Tich (page 23). Like Lautrec, almost a dwarf, Harry Tich was nevertheless an acrobatic dancer. Walter Sickert recalled seeing the two of them on holiday in Dieppe, 'where they frightened women on the pier by their deliberately offensive behaviour'. Such escapades began to worry Lautrec's family, and his dependence on alcohol increased, to the extent that he carried a cane with a hollow inside filled with cognac, the silver top a small cup that unscrewed; by 1899 he was confined for an alcoholic cure in a clinic in Neuilly.

While there, and while friends tried to get him 'released', Lautrec drew from memory a series of circus scenes which are not only among his most vivid work depicting the nightlife of Paris, but also served to encourage the doctors to let him go. Anyone capable of such sustained work, they surmised, must be cured. It was not so. By the summer of 1901 he was so weakened by the effects of alcohol, his existing disabilities, and the effects of venereal disease, that he put his studio in order, and returned to his mother's house to die.

Little Tich (1867–1928) became an Officier de l'Académie in Paris

With his passing, so too the nightlife of Paris was to alter. The management of the Moulin Rouge closed down the old dance-hall in 1902, replacing it with a conventional music-hall. Entertainments that had once been for the people of Paris were now increasingly designed to amuse tourists, and many of the venues that had once been dance halls, cafés or cabarets were converted into cinemas. By the mid-1920s when the great panels Lautrec had painted to advertise La Goulue's appearances at the Foire du Trône entered the national collection, the old dancer, disfigured and poverty-stricken, was selling matches on a street-corner. Bruant returned to Paris just once after the Great War, to enjoy a last triumph, singing his old songs on the stage of the Empire. Yvette Guilbert continued to work until the time of her death in 1944, when she lived in seclusion in Aix-en-Provence, in terror lest the Occupation authorities should arrest her husband, who was Jewish. Yet every month she took the bus to Marseilles to broadcast a talk. Her voice still rich, she would sit before the microphone and unfold another page from her reminiscences of that Paris nightlife of which she had been the brightest star, and whom Lautrec had painted and drawn in all her glory. Perhaps remembering Lautrec's advice from all those years ago, she said, 'If friendship can produce gaiety, it's sad that love has never been known to raise a laugh ...'; but reeling off the names of her painters and poets, she concluded one talk: 'that astonishing Bohemia that drew all the arts together in one collaborative aim: to laugh, to enjoy with spirit.'

The climax of the quadrille: *le grand écart* – the splits

The Plates

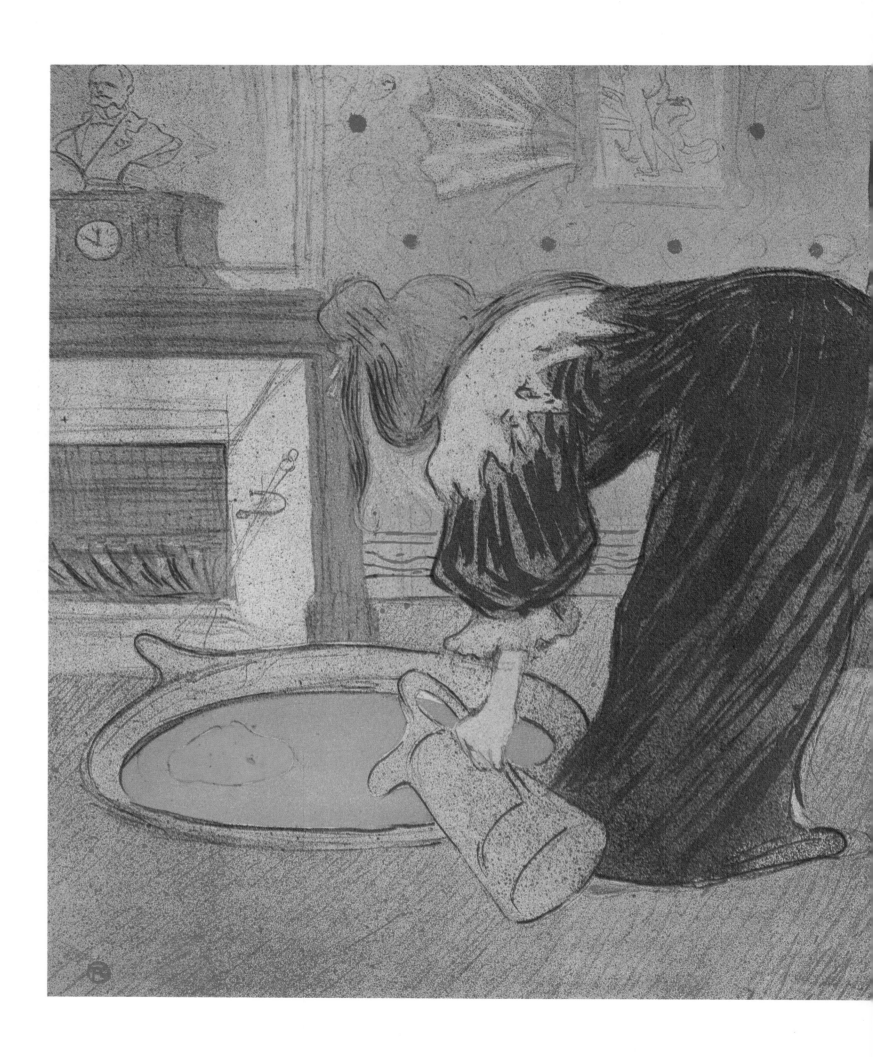

Plate 1

Woman with a Bathtub

*1896, coloured lithograph, 40 × 52.5 cm (15¾ × 20¾ in),
Paris, Bibliothèque Nationale*

For a lady of the night, whether, as in this lithograph from the series *Elles*, she was an inmate of a brothel, or whether she plied her trade from an elegant apartment or under cover of a career on the stage, the day probably began late. Emilienne d'Alençon (page 68), a celebrated courtesan of the 1890s, who had a brief flirtation with the stage, when Lautrec drew her, numbered the King of the Belgians, Leopold, among her admirers. When he called on her one morning, His Majesty was solemnly informed by the butler that his mistress did not receive callers before eleven. The King was said to have replied, 'Let her sleep. I'll come back after Mass and take her to luncheon.' Such honours would not have been enjoyed by the young woman in this graceful study. Although she may have had the luxury of the maid-of-all-work in the house carrying the jug of hot water upstairs for her, she is having to pour it into the sponge-bath herself. These flat tin baths were designed so that the bather might stand in the centre, sometimes on a specially constructed stool, and squeeze water from a large sponge, making an attempt at a shower. *Elles* was published in 1896 by Gustave Pellet, and with the exception of one plate, showing Cha-U-Kao resting after her performance, all the lithographs were scenes inside the brothel. Lautrec's famous technique of stippling the lithographic stone by using a toothbrush soaked in ink and teasing the dots onto the stone with his finger can be seen here. The preparation for the evening, even if one was going no further than downstairs, involved a great deal more work than it might today, considering the fashions in hairstyle and corsetry in the late 19th century.

Narcissism or seductiveness?
A boudoir photograph by
Gaston & Mathieu, Paris,
c. 1880

Plate 2 **Monsieur Boileau in a Café**

1893, oil on canvas, 80 × 65 cm (31½ × 25½ in), Cleveland Museum of Art

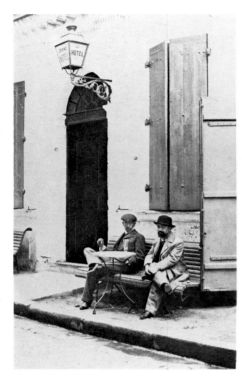

Lautrec and Paul Guibert, an early evening drink in 1892 (Bibliothèque Nationale)

While women in the 1890s were required of necessity to spend hours preparing their elaborate costumes for the evening, the men might spend their time at the café. Boileau was a well-to-do merchant who frequented cafés and cabarets in Montmartre. He was said to end up the evening at Le Mirliton in such a state of emotion, that he had to be escorted out into the street to a waiting car. Like Degas, Manet and Anquetin, Lautrec has used absinthe as the theme for this study of the incipient alcoholic. The whole picture is suffused with a greenish tinge, which draws the eye to the full glass in the very foreground. Boileau's puffy cheeks, debauched pose, the cigarette dangling from his right hand, all suggest the outcome of the evening. Absinthe, the drink that haunted all the late 19th-century painters and poets, was eventually outlawed because of its dangerous properties. Before this there was a health campaign in France with posters declaiming 'Absinthe rend fou' ('Absinthe makes you mad'). George Moore, an habitué of the cafés of Montmartre such as the Nouvelle Athenes evokes such a scene in *Confessions of a Young Englishman*: 'In the morning, eggs frizzling in butter, the pungent cigarette, coffee and bad cognac; at five o'clock the vegetable smell of absinthe; after the steaming soup ascends from the kitchen and as the evening advances, the mingled smells of cigarettes, coffee and weak beer.' Lautrec's own drinking habits ranged from his own admission, when on a trip to Amsterdam in 1894, that the quantity of beer he and his companions were drinking was 'incalculable' to his fondness for a local wine that his mother obtained from one of the vineyards near Albi, of which he calculated that he drank a barrel and a half a year.

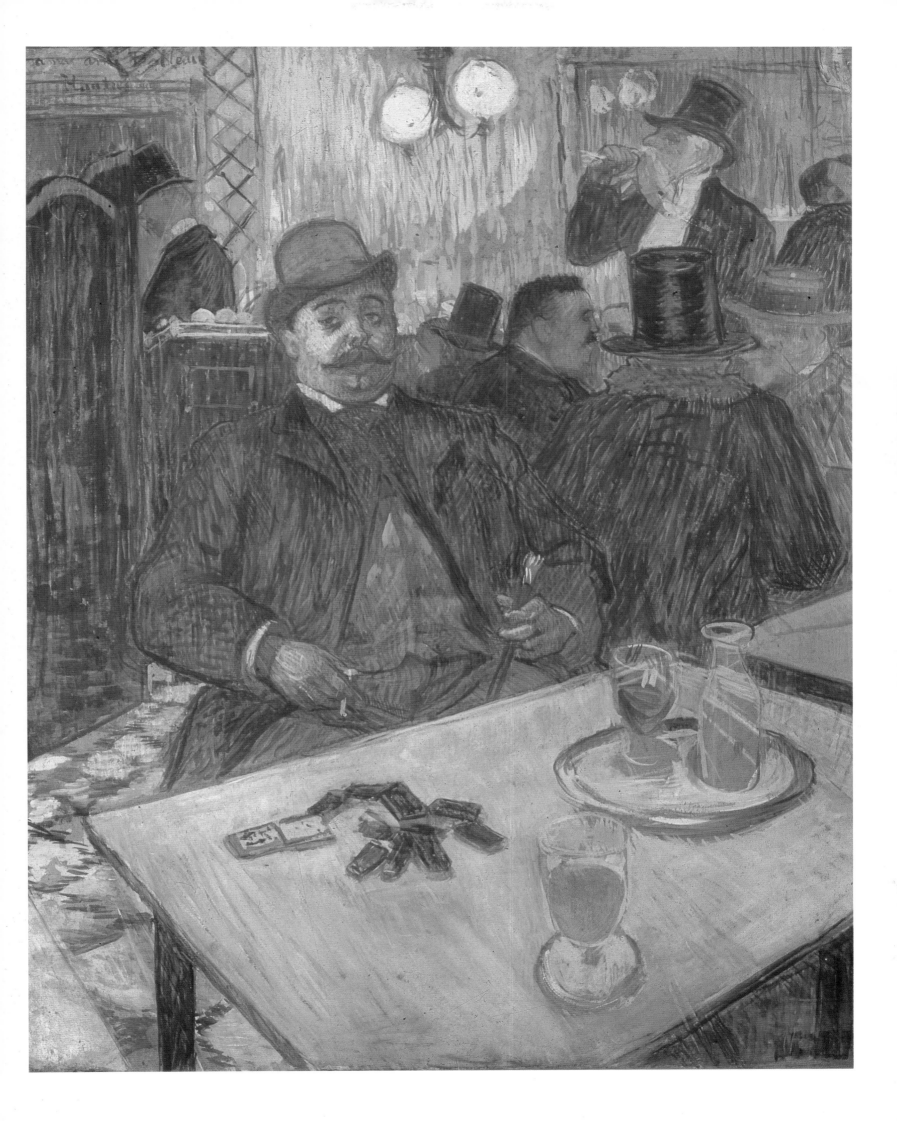

Plate 3

Maxime Dethomas

1896, oil and gouache on cardboard, 67.5 × 52.5 cm
(26½ × 20¾ in), Washington, D.C., National Gallery of Art

The costume for masked balls
was decorous but flirtatious

Maxime Dethomas the lanky painter and engraver, was a close friend of both Lautrec and Vuillard. He was said to be very shy; Lautrec described him as someone 'who doesn't talk about his painting, something that is very praiseworthy.' Degas admired his work and said 'it had weight'. Lautrec nicknamed him 'Gros Narbre' ('the big tree'?). In this portrait Lautrec has caught the man's reticence, including his choice of dark grey suits—part of his fear of drawing attention to himself. The implication is that his presence at such an indiscreet venue as the Opéra ball might further compromise his diffident sociability. Lautrec made a number of studies of dancers and partygoers at the masked balls at the opera. The traditional domino costume that the figure on the right is wearing, like the unidentified beauty in the photograph makes a demure contrast with the bold stance of the girl in the body stocking and mask. She strangely foreshadows the figure of Musidora as Irma Vep in *Les Vampires*, or a character from Colette's story *The Hidden Woman*, in which the hero 'wandered down all the corridors of the Opéra, had drunk in the silvery dust of the dance floor ... and wrapped around his neck the indifferent arms of a very fat girl humourously disguised as a sylph'. The Palais Garnier had opened in 1875 as the most ostentatious opera house in Europe. The opera balls became such a fixture that they inspired Heuberger's famous operetta *Der Opernball* in 1898. The music played for the dancers was usually specially-arranged potpourris of favourite tunes from operas, transformed under the baton of bandmasters like Métra, who had been at the Elysée-Montmartre and the Folies-Bergère, into quadrilles, polkas and waltzes.

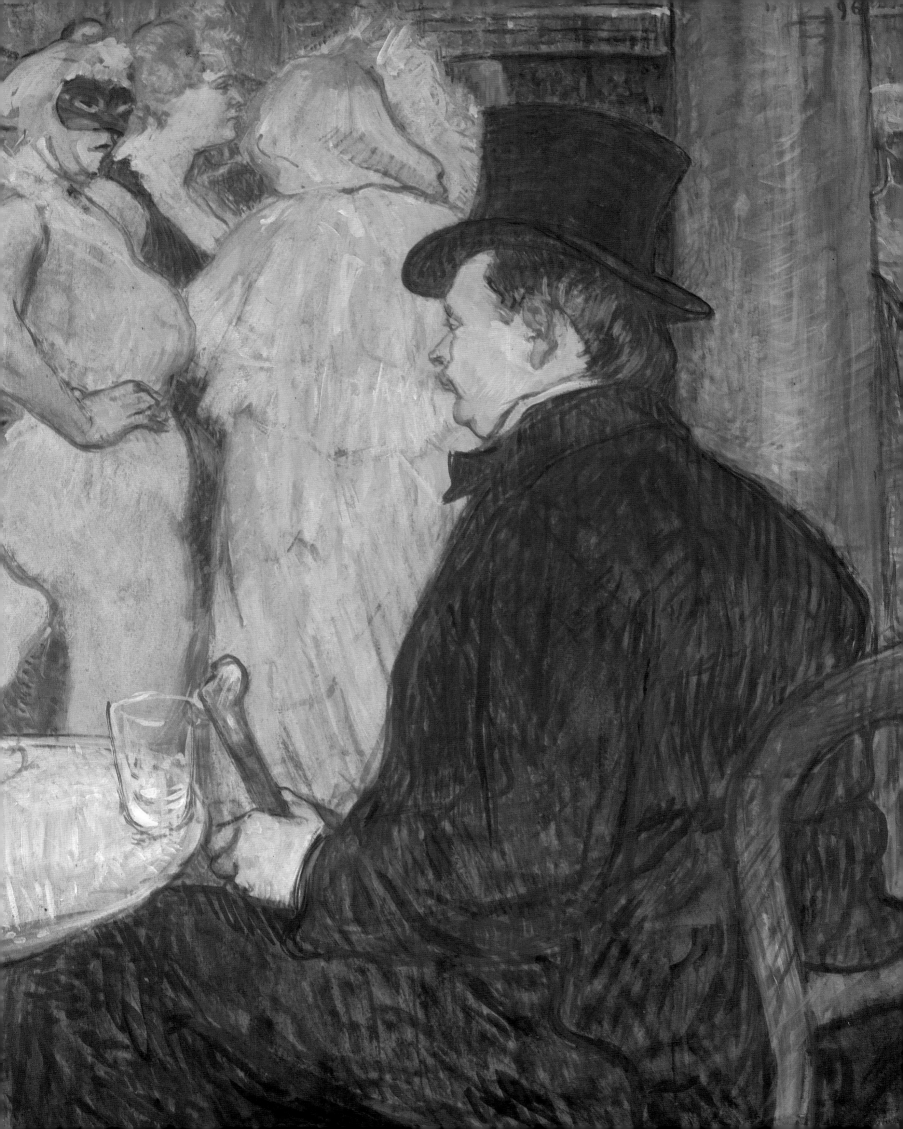

Plate 4

The Englishman at the Moulin Rouge (William Tom Warrener, 1861–1934)

1892, oil and gouache on cardboard, 85.7 × 66 cm
(33¾ × 26 in), New York, The Metropolitan Museum of Art

Lottie Collins (1870–1910),
pandering to the English idea
of French naughtiness

Like several other portraits of dapper men-about-town that he painted in the early 1890s, Lautrec's treatment of the English businessman Warrener is slyly ironic. Is it just imagination on the viewer's part, or is there a sense of that supposedly English reserve being conquered by the gentleman's conversation, or is it bargaining, with the two girls? As a password for naughtiness, the notion of a visit to Paris became a dramatic and literary cliché, and has so remained. Leslie Stuart's song 'I went to Paris with Papa' tells the story of a strictly-brought up young lady whose father takes her to Paris to improve on her provincial accent acquired at finishing school. She learns a bit more than is bargained for, smoking, sitting on young men's laps and kicking up her heels. 'Such funny ways they've got, which Englishmen have not,' she sings. Lottie Collins specialised in high-kick dance routines, the most famous being 'Ta-ra-ra-boom-de-ay!', and was the mother of the famous operetta primadonna, José Collins. Lautrec's own anglophilia led him to cultivate the company of businessmen such as Warrener (this painting was also made into a lithograph) as well as performers and artists. Lautrec visited London in 1892 and was suitably impressed by the libraries and art galleries, though understandably appalled by the dreariness of an English Sunday: everything was closed, even hotels seemed reluctant to serve a meal. When he returned to London in 1898, for an exhibition at the Goupil Gallery, he chose to paint not an actress or demi-mondaine, but the barmaid at the local pub.

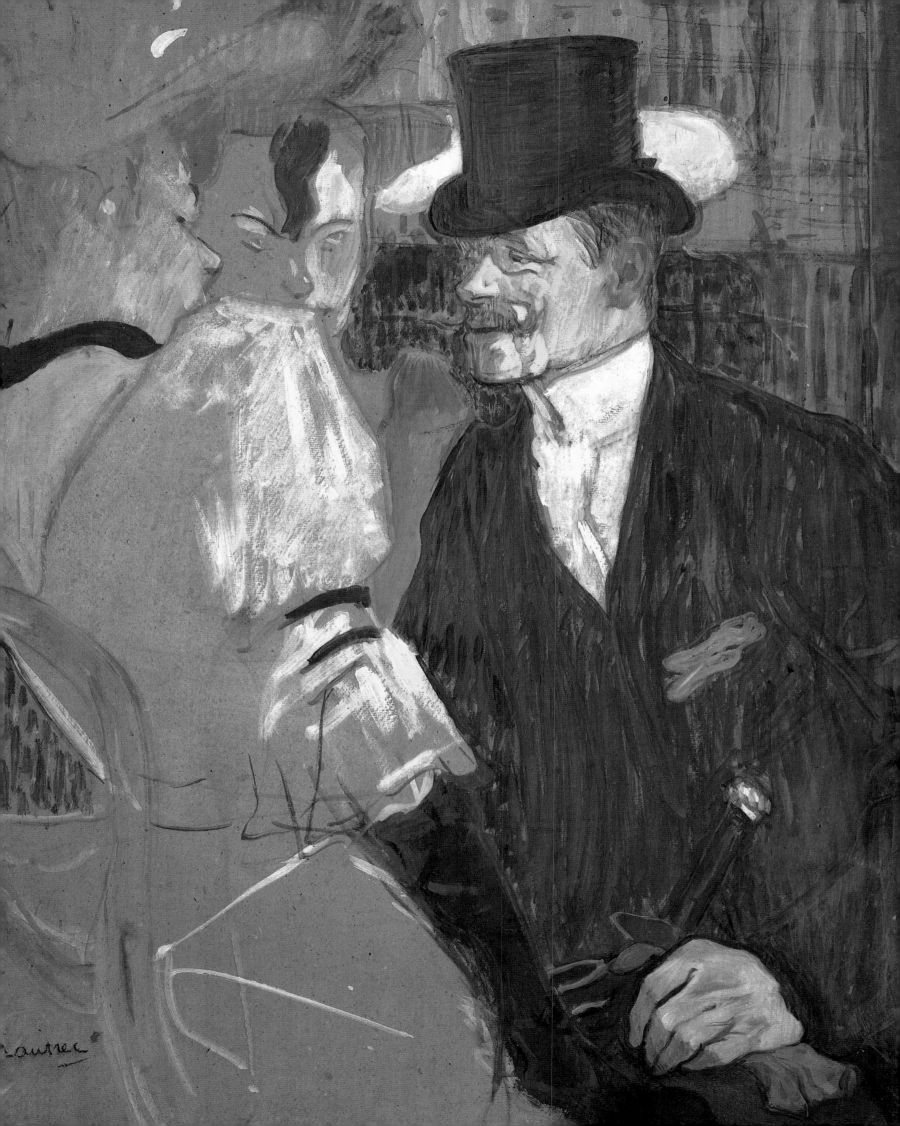

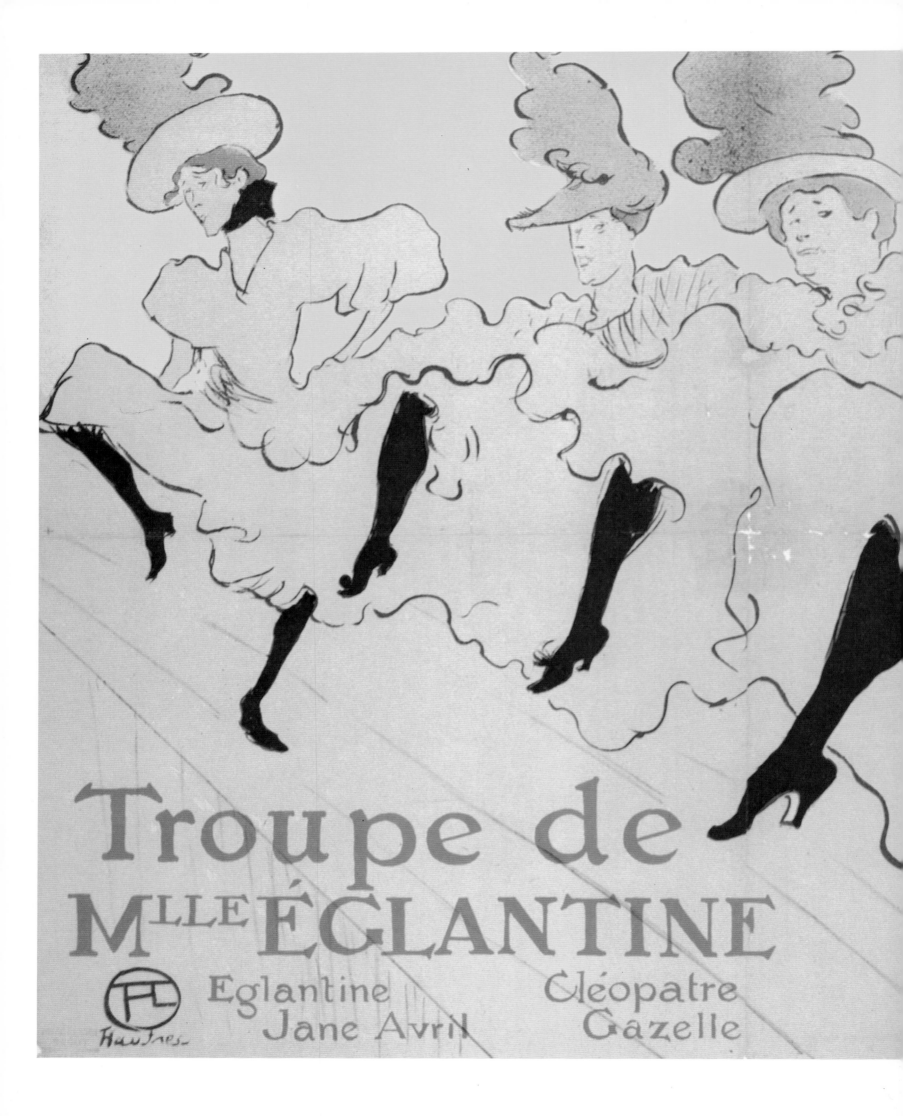

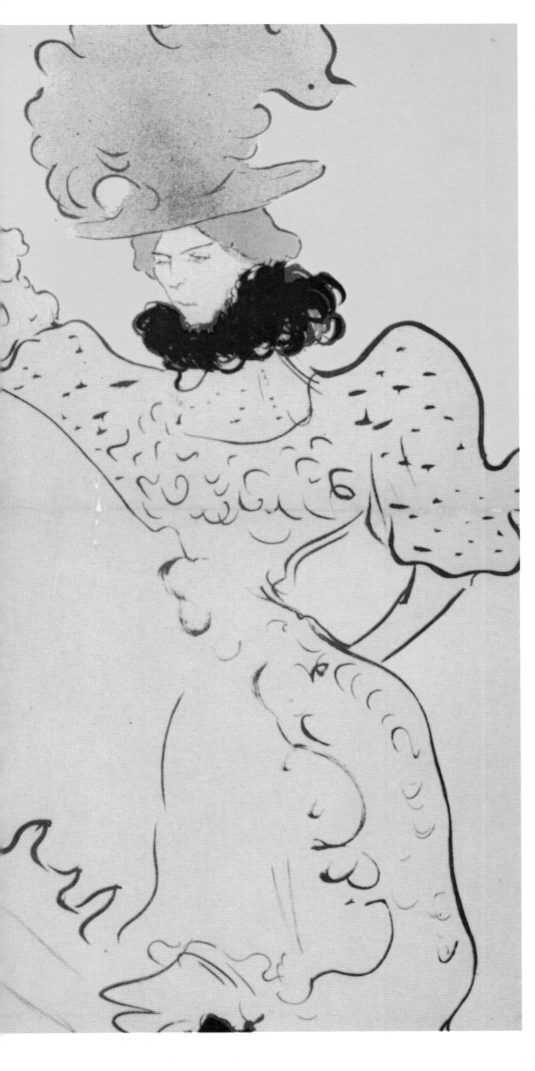

Plate 5

The Troupe of Mademoiselle Églantine

1896, coloured lithograph, 61.7 × 80.5 cm (2¼ × 31¾ in)

This poster was commissioned for Jane Avril's first appearance in London in 1897 at the Palace Theatre. This was a very prestigious engagement, the Palace was the grandest music-hall in the West End, its proprietor, Charles Morton was known as 'the Father of the Halls'. Églantine, the leader of the quartet whose name gave the troupe its slogan had been, like Jane Avril, a dancer in the popular ballrooms of Paris. According to Jane Avril's biographer, José Shercliff, only she and Jane enjoyed a real success in London, and the other two, the provocatively named Cléopatre and Gazelle were quick to show their resentment and pick a quarrel in the dressing-room at the theatre. 'It was only when a horrified dresser summoned the director himself that peace was restored. Morton, with consummate tact soothed them down, praised the two despised dancers in glowing terms—winking at Jane over their heads as he did so—and invited the party to a champagne supper to celebrate their reconciliation.' Jane Avril, of all the Montmartre dancers, was the one with whom Lautrec had the closest friendship, her melancholy appearance, and stylish dramatic dancing, made her as attractive a subject for theatrical as well as portrait studies. He depicted her as a member of the audience in his poster for the Divan Japonais, and seen from behind, watching Bruant in his project for the Ambassadeurs poster (Plate 22). One of her greatest successes was in a production of Ibsen's *Peer Gynt*, staged by Lugnë Poé at the Nouveau Theatre in the rue Blanche. Her performance of Anitra's dance brought applause and a memoir in the form of a poem by Pierre Charron,

> Tu sembles une fleur balancée, troublante
> Au souffle du vent chaud qui l'endort doucement

Jane Avril made her final appearances in Paris as late as 1935 'Her very strangeness roused strange desires,' wrote Shercliff, 'and drew men and women of all kinds around her.'

Plate 6

Detail from At the Moulin Rouge: Two Women Dancing

1892, oil on canvas, Prague, National Gallery of Art

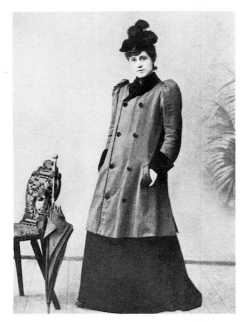

Jane Avril (1868–1943), nicknamed 'La Mélinite', after the explosive

Pierre Mac Orlan wrote of his first glimpse of the Moulin Rouge: 'It is difficult to evoke its silhouette without reliving a whole era, which was neither kind nor loving, but which attained the full degree of civil liberty.' Its early years, immortalized in Lautrec's work, began to decline in 1895 with the departure of La Goulue. Although it continued in its original form until 1902, as a dance-hall with adjacent pleasure-garden and open-air café-concert, the increasingly hectic ploys of the management to attract tourists and cling to the locals are catalogued in the long list of *Redoutes*: Saturday-night masked balls, with themes like 'The return to Mecca', 'La Vache enragée' ('The Angry Cow') or 'Falbalas et poudre de riz' ('Falbalas and Rice-powder'), during which there would be staged tableaux, all the maskers sometimes joining in a parade (see engraving reproduced on Endpapers). The dance-hall was naturally somewhere where people went to show off their clothes as well as to indulge in fancy dress. The figure in the red jacket has been identified as Jane Avril: she is in the high fashion of the time, with the leg-of-mutton sleeves which, according to the fashion historian Alison Gernsheim, began in 1892 'to grow in earnest', and which by the end of the decade would be so overblown that women had to pass sideways through doors. The day-clothes Jane Avril is wearing in the photograph are similar to those that Lautrec painted her in, a sad expression on her face, departing alone from the dance hall. Jane Avril was renowned for her unusual flair for using colour in her costumes; unlike the other dancers her petticoats were not white, but in shades of pastel, her slim figure went without corsets, and she often improvised a solo to one of the waltzes played by the orchestra.

Plate 7

Detail from Quadrille at the Moulin Rouge

1892, gouache on cardboard, Washington, D.C., National Gallery of Art

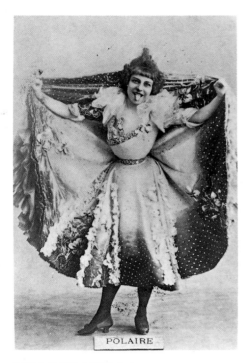

Polaire (1877–1939), before she took on the role of Claudine

Even after it was turned into a theatre, the great attraction at the Moulin Rouge was the quadrille. Its acrobatic steps, the competitive element, the dancers rivalling each other with high kicks, *fouetés* and the splits (page 24) ensured that it was, and has remained in its more choreographed form as the Can-Can, a byword for eroticism. That at the beginning all the participants were well-rehearsed amateurs, drawn from local young men and women working off their pent-up energy in the fury of the *Chahut*, also gave the dance a further reputation as a refuge for women of loose morals. In this painting, the moment before the dance begins is clearly felt. The hesitant-seeming girl in the foreground, her demure expression and formal clothes about to be contrasted with the abandon of the dance, is literally and figuratively the opposite of the aggressive, somewhat mannish-looking woman, her skirts already raised, awaiting the opening bars of the music. By the mid 1890s professional dancers were adapting the steps, postures and flamboyant gestures of the dance into their music-hall turns. Among them was the Algerian-born Polaire, reputed to have a 16-inch waist, and, although a sensually attractive personality, billed as 'The ugliest woman in the world'. Lautrec drew her on a number of occasions, she appeared at most of his favourite haunts, the Moulin Rouge, Ambassadeurs and Eldorado. Polaire was destined to have a long and distinguished stage career, including a close friendship with Colette; she played the role of Claudine in both the play and the operetta adapted from Colette's most famous character. 'Her approach to her art was unusual,' wrote Colette. 'She understood all the more delicate shades, the subleties, the thoughts that were suggested, half concealed and expressed them to perfection.' In this lively photograph, with her hairstyle, which seems to hark back to the 18th-century Pulcinella, and her tongue sticking out, she is exactly as Colette described seeing her in the music-hall, 'screwing up her body like a wasp in a jam pot, her lips smiled convulsively, as though she had been sucking a lemon'.

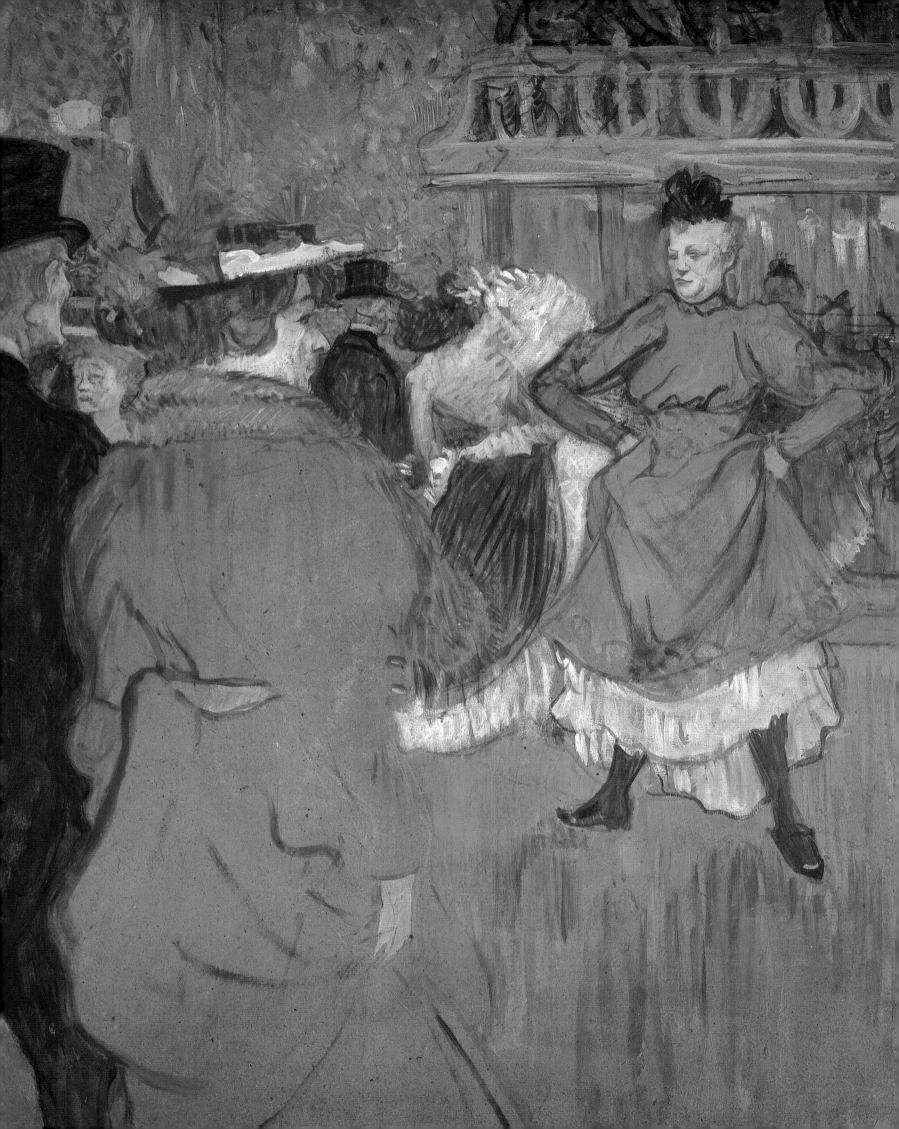

Plate 8

Detail from The Box with the Golden Mask

1893, oil on canvas, Albi, Musée Toulouse-Lautrec

Antoine (1858–1943),
founder and director of the
Théâtre Libre

Lautrec's enthusiasm for the theatre had been kindled when he was very young, and he wrote an enthusiastic account of a performance of *Le Cid* when he was 12. Judging by the number and variety of his studies of actors and actresses in both modern and classical plays, his attendance at the theatre must have been frequent. The audience caught his attention for many paintings also, such as the one of his cousin, Dr Gabriel Tapié de Céleyran, lurking in the corridor of the Comédie Française (page 5). This painting of the occupants of a box decorated with a golden mask is a study for the programme cover of the Théâtre Libre production of Marcel Luguet's play *Le Missionnaire* in 1893. The company of the Théâtre Libre, founded by Antoine, in 1887, was at this time playing at the Menus-Plaisirs theatre on the Boulevard de Strasbourg. This theatre, which was eventually re-named the Théâtre Antoine, had been redesigned in the early 1880s by Delignière; Lautrec drew Antoine himself on a number of occasions and also produced another programme cover for the production of Emile Fabre's play *L'Argent*. The production of *Le Missionnaire* was not a success; Antoine was the narrator and introduced fragmented scenes from a plot too complicated to follow. Like his contemporary Lugné-Poé, at the Théâtre de l'Oeuvre, Antoine was one of the pioneers of modern stage design in Paris. In 1890 he wrote that the French were 'still in their infancy where the art of scenic illusion was concerned.' Lautrec designed sets for at least two plays, one, *Le Chariot de terre cuite* at the Théâtre de l'Oeuvre: 'It's very interesting,' he wrote, 'but not easy'.

Plate 9

Loïe Fuller in 'Dance of the Veils' at the Folies Bergère

1893, oil on board 63 × 45.5 cm (25 × 18 in), Albi, Musée Toulouse-Lautrec

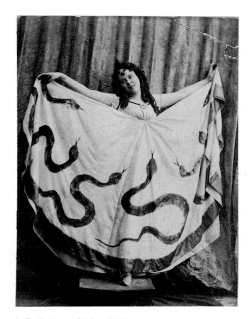

Loïe Fuller (1862–1928): in costume for the snake dance

Credited by theatre historians as one of the most influential pioneers in the use of electric light on the stage, the American dancer Loïe Fuller first appeared in Paris at the Folies Bergère in 1892. Her act was quite simple. She would execute a dance—in Lautrec's painting it is the 'Dance of the Lilies', in the photograph the 'Snake dance'—which inevitably involved a spectacularly voluminous skirt made of fine silk. The use of glass panels, which, when alternated in front of the concealed spotlights at the side of the stage, and sometimes under a glass panel over which Loïe Fuller would swirl, created a magical effect. It has been copied thousands of times since. Mallarmé was bowled over by her and wrote of her ability to 'unite the flight of her garments to the force of the dance'. Jean Lorrain claimed that: 'Wrought in a fiery furnace, Loïe Fuller did not burn, she was herself the flame.' Lautrec made a lithograph after this painting, each copy of which he had sprinkled with gold-dust to attempt an evocation of Fuller's lighting effects. Her career continued across Europe, with a band of pupils to whom she imparted her secrets. Some said too well, for the company double-booked on occasion and were caught out by a management who found that they had appeared in different cities on the same night. It was the lighting effects and the costumes, rather than the dancer herself that entranced the public. One of Loïe Fuller's pupils was the famous *chanteuse* Damia, who brought to the *tour de chant* the dramatic use of spotlights that she had studied with Fuller. Loïe Fuller's last years were sad; her eyesight affected by her experiments with chemicals, she died in obscurity. But, thanks to Lautrec and Beardsley, who also drew her, she remains one of the romantic figures of the 1890s, who still inspires poets, like Richard Howard who wrote his *Famed Dancer Dies of Phosphorus Poisoning* in 1988.

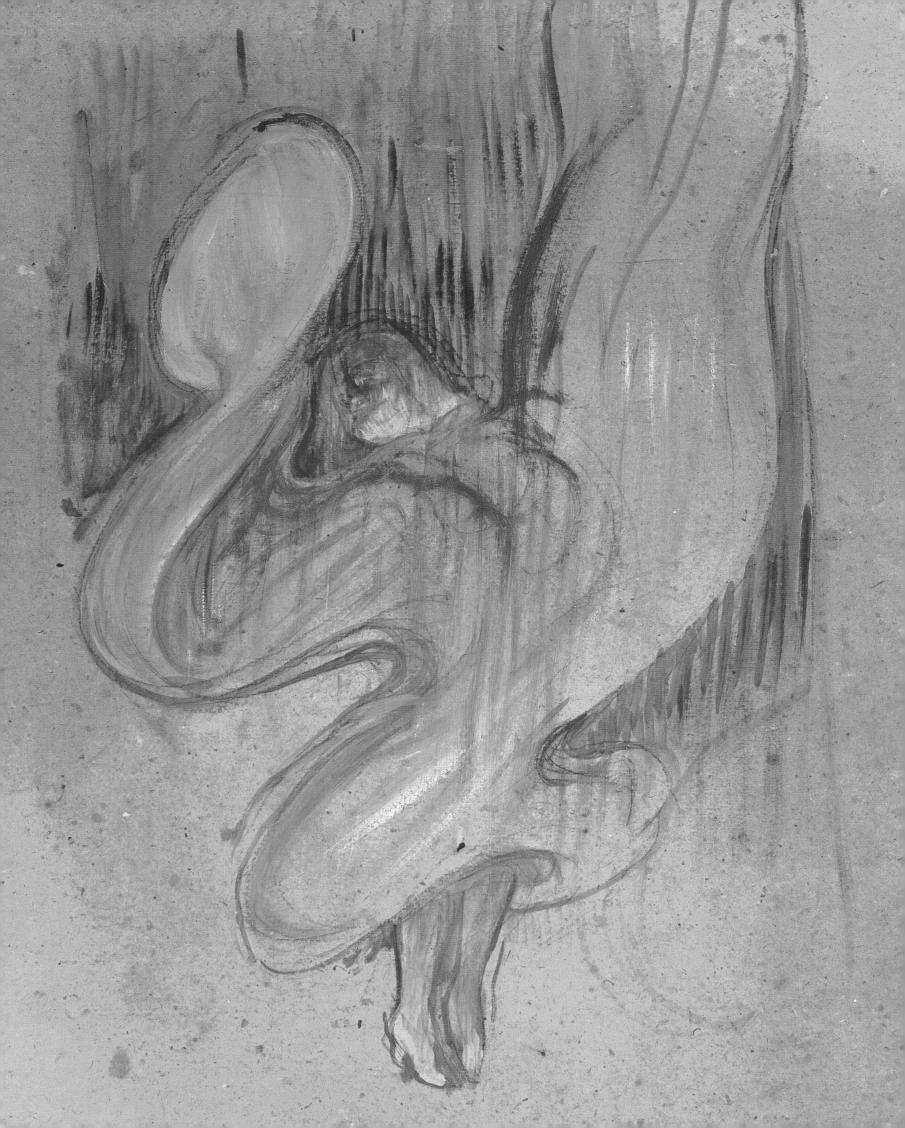

Plate 10

Messaline on the Throne

1900, oil on canvas 46 × 61 cm (18 × 24 in), Albi, Musée Toulouse-Lautrec

Isidore de Lara's opera *Messaline* was first performed in Monte-Carlo in March 1899. It was given in London the same year, and was destined to become the first opera by an Englishman to be performed at La Scala, Milan, in 1901. When Lautrec saw it, at the Bordeaux opera in 1900, during the winter season, he was as much attracted by the primadonna, Mlle Ganne, as by the luxurious Roman settings. He executed six paintings of the opera; its story of the Empress Messalina's erotic adventures, which culminate in a fight between two of her lovers, must have amused him as much as that other parody of classical mythology, Offenbach's *La Belle Hélène*, two productions of which he drew and painted. These late theatrical paintings have generally been criticised as inferior examples of Lautrec's work. His declining health, which had only been exacerbated by the attempted cure for alcoholism that he had undergone the previous year, seems nevertheless not to have diminished his energy for painting—though the results were uneven. In English, he wrote to Maurice Joyant in December 1900, 'I am fascinated by this opera, but the more documentation I have, the better my work will be.' Mlle Ganne, he said, had a 'burning look', but his enthusiasm which he expressed volubly throughout the performance, discomforted his neighbours in the stalls who tried without success to make him be quiet. Lautrec, with his passion for all that was uninhibited and modern in the performing arts, can only have had an ironic interest in the formality of the operatic stage. As well as *Messaline* and *La Belle Hélène*, he also drew other opera singers in Paris, among them Rose Caron, Sybil Sanderson and Juliette Simon-Girard.

Isidore de Lara (1858–1935); his other operas include *Amy Robsart*

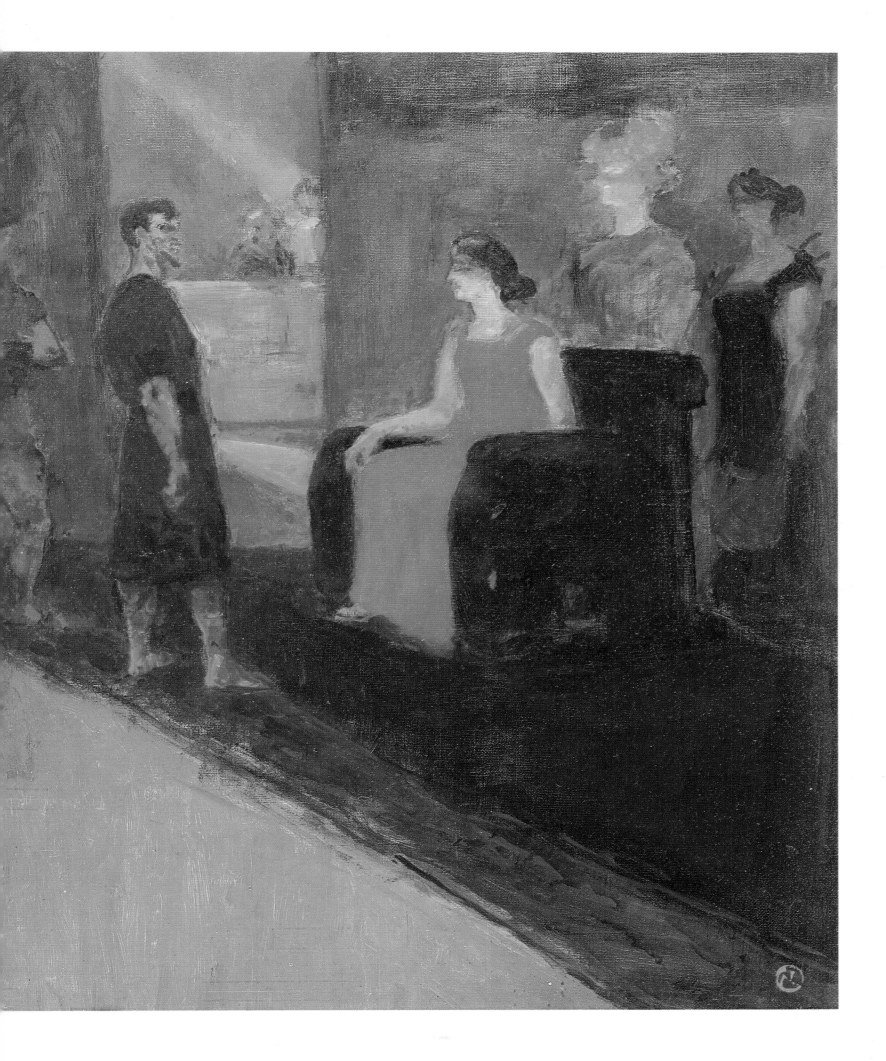

Plate 11

The Ballet

1886, oil on canvas, 102 × 150 cm (40¼ × 59 in),
Stockholm, Thielska Galleriet

Lautrec was profoundly influenced by the work of Degas and this early painting is obviously an attempt to achieve something of Degas's success with studies of the ballet. It was painted in the same year in which Lautrec's first work was published, among which was an illustration of the quadrille at the Elysée-Montmartre. It is apparent that for all Lautrec's admiration for the older painter's technique and innovation, the world of *ballet blanc* held little interest for him, and he seems never to have returned to the subject in the 1890s, even when he made a portrait of the most famous ballerina of the time, Cléo de Mérode. Like some of the other female performers Lautrec knew, her fame did not rest entirely upon her terpsichorean ability, but also on the racy reputation that she enjoyed. In her autobiography, *Le Ballet de Ma Vie*, published in the 1950s, Cléo de Mérode remembered that many painters would come to the wings of the Opéra to sketch, during rehearsals as well as during the practice classes. The sketchers, she recalled, seldom attempted a portrait but always drew groups of dancers. Eventually she posed for Degas and Forain; she said that she would go several times a week to Degas's studio. Cléo de Mérode enjoyed a very long career. After the First World War, she reappeared in a revue called *1900* and danced an elegant waltz in which, according to contemporary critics she had lost none of her charm. In the 1950s she sued Simone de Beauvoir who had referred to her in *Le Deuxième Sexe* as 'that great Hetaera'. The courts awarded Cléo de Mérode the symbolic franc in lieu of damages. 'How her swains of long ago would have laughed,' wrote the impresario Paul Derval, 'they who had laid gold at her feet, and whose carriages blocked every street around the Folies Bergère!'

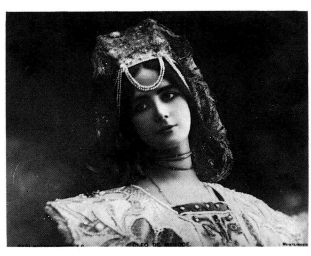

Cléo de Mérode
(1878–1965); prima ballerina
of the belle époque

Plate 12

Les Grands Concerts d'Opera: Ambroise Thomas at a Rehearsal of 'Françoise de Rimini'

1896, chinese ink and charcoal on paper, 87 × 63 cm (34¼ × 24¾ in), Albi, Musée Toulouse-Lautrec

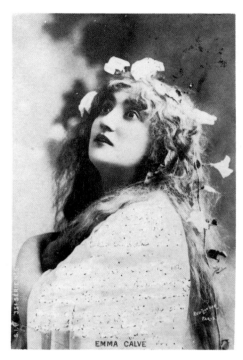

Emma Calvé (1858–1942),
as Ophelia in Ambroise
Thomas's *Hamlet*

Lautrec's reaction to music was eccentrically subjective and he does not seem to have usually been attracted to the opera at the Palais Garnier, however much he may have enjoyed performances of a lighter nature of the operettas of Offenbach, Hervé and others. This study was the first stage for an illustration in Arsène Alexandre's journal *Le Rire*, and is especially interesting as it shows the veteran composer of *Mignon* aand *Hamlet* at a rehearsal for the last of his operas that he was to see performed; he died shortly afterwards. *Françoise de Rimini* had first been given in 1882, when by ironic coincidence the poster had been executed by the same Jules Chéret who was to precede Lautrec as *affichiste* for the Moulin Rouge. The pomposity of the composer's profile as he listens to the singer's performance is somewhat softened by the distraction provided by the jaunty boater trimmed with feathers. This belonged to Misia Natanson, at whose house Lautrec spent long periods, and painted several portraits of her, as well as depicting her skating in a poster for her husband, Thadée's magazine, *La Revue Blanche*. Misia recalled that Lautrec loved hearing her play Beethoven's incidental music to Kotzebue's *Die Ruinen von Athen*. 'Ah, the beautiful ruins, the wonderful ruins; once more the ruins, Misia!' Ambroise Thomas's *Hamlet*, after his *Mignon*, has retained its popularity, especially because of the spectacular Mad Scene, beloved of sopranos from Melba to Callas. One of Lautrec's subjects was the French soprano Emma Calvé, seen here as Ophelia. She had first sung the role in the presence of the composer in Nice in 1885. The success was so great that composer and cast were called back more than 30 times. Lautrec was just as likely to walk out halfway through a theatrical performance when he had seen enough to amuse him or to spark off an idea for a picture.

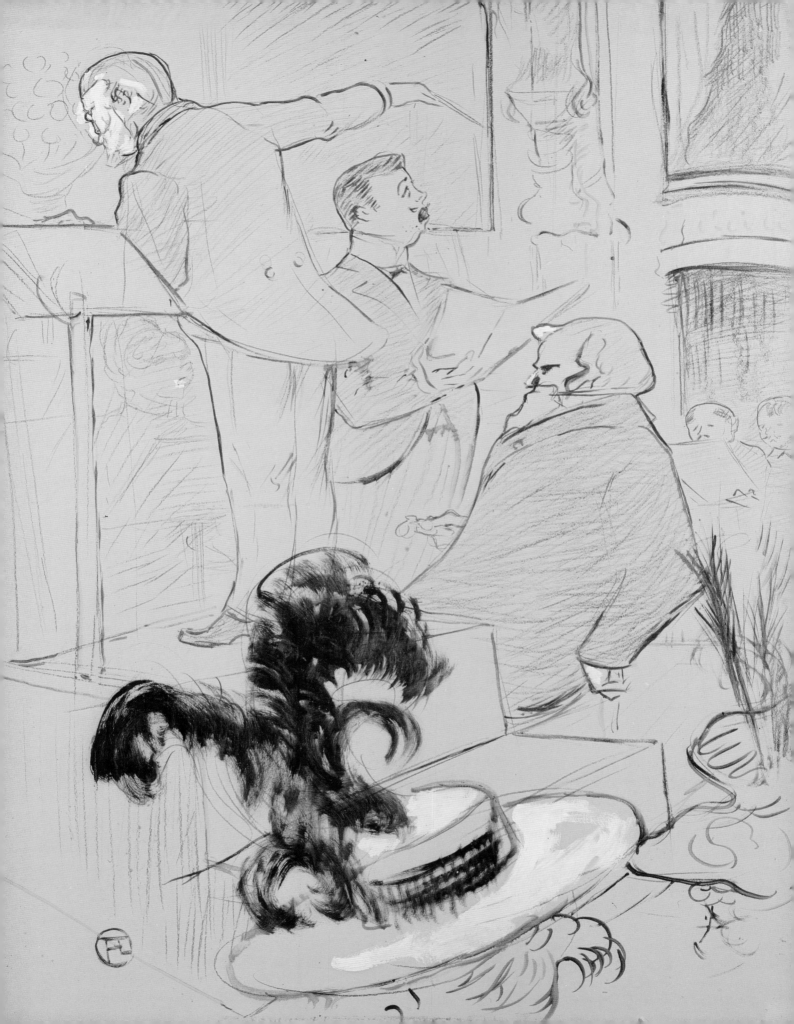

Plate 13

Marcelle Lender dancing the Bolero in 'Chilpéric'

1895, oil on canvas, 145 × 150 cm (56¾ × 59 in), New York, the Collection of Mrs John Hay Whitney

The remarkable back of Marcelle Lender

Lautrec had first seen Marcelle Lender play at the Variétés in *Madame Satan*, in which he drew her in the role of Rosalinde. Her performance as Galswinthe in the revival of Hervé's *Chilpéric* made her a star. The bolero, 'A la Sierra Moréno', in which she is seen dancing, is part of the action of this satire on operatic plots involving Druids and visiting Royalty. The opérette had first been given in 1868; the composer Hervé was in the title role, which calls for a singing actor of great skill, who has to deliver his most famous aria, the 'Chanson du jambon' on horseback. In this revival it was played by Albert Brasseur, and Lautrec made a lithograph of him in his big number. Lender seems to have fascinated Lautrec almost as much as Yvette Guilbert or Jane Avril for he painted and drew her again and again. Born in 1862, she had had one of her earliest successes in St Petersburg, then returned to Paris and played at various theatres, including the Palais Royal and the Nouveautés. Equally successful in comedy and operetta, she sang in Lecocq's *La Fille de Madame Angot*, Offenbach's *La Vie Parisienne* and *La Chanson de Fortunio*. Lautrec was said to have attended at least 20 performances of *Chilpéric*, always sitting in the same seat on the left-hand side of the orchestra stalls. 'I come just to watch Lender's back,' he said, 'look at her carefully, you'll never see anything else like it.' Not content with seeing her across the footlights Lautrec took Marcelle Lender to dine after the performance several times at the Café Viel. She found his manner disconcerting and, according to reminiscences she told many years later, he made no mention of the painting upon which he was working. Unfortunately, like many of his other models, she was not flattered by the result. When she died in 1927 not even one of Lautrec's lithographs was among her possessions.

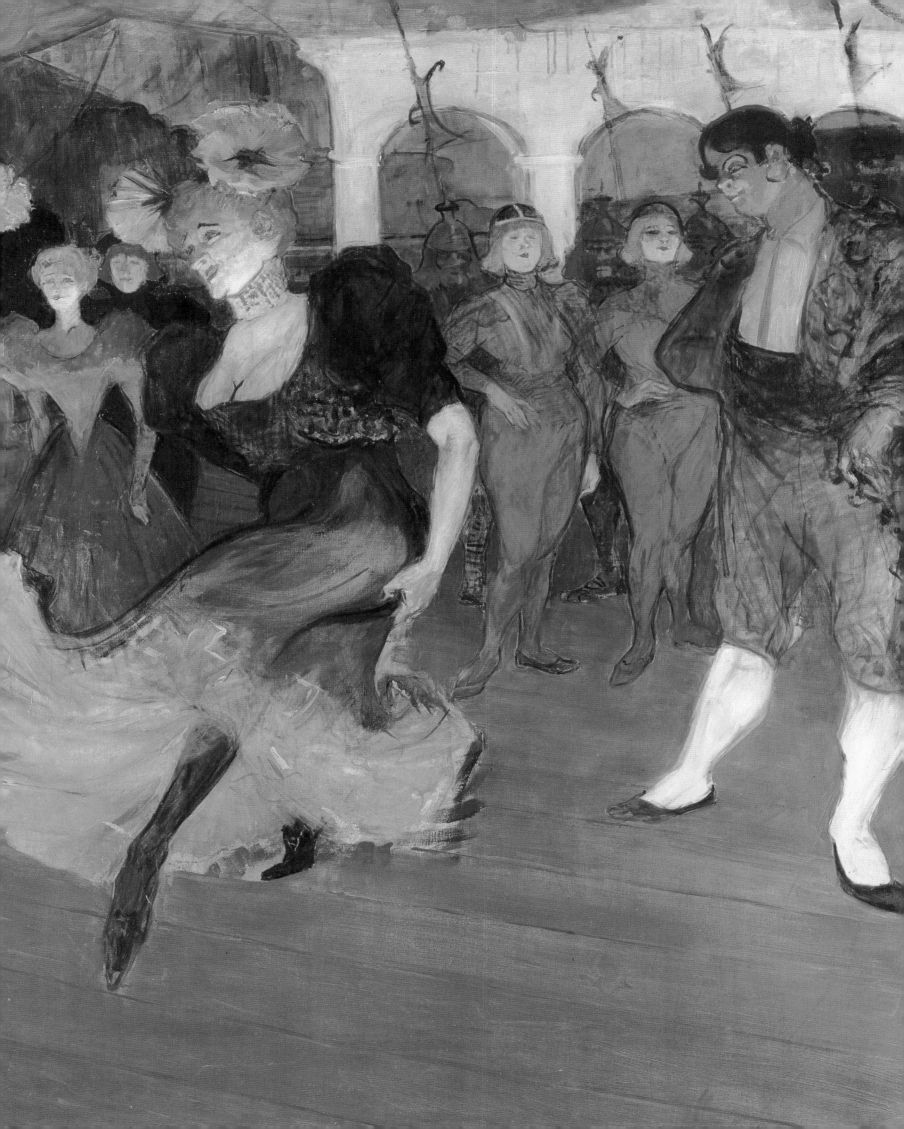

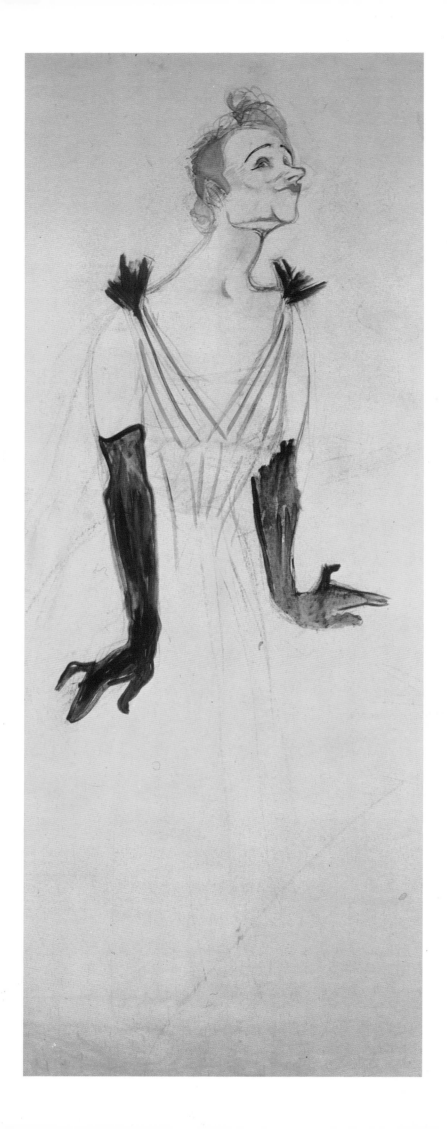

Plate 14

Yvette Guilbert

1894, charcoal and chinese ink on paper, 186 × 93 cm (73¼ × 36½ in), Albi, Musée Toulouse-Lautrec

At the Ambassadeurs

That was Yvette. The blithe Ambassadeurs
Glitters, this Sunday of the Fête des Fleurs;
Here are the flowers, too, living flowers that blow
A night or two before the odours go;
And all the flowers of all the city ways
Are laughing with Yvette, this day of days.
Laugh with Yvette? But I must first forget,
Before I laugh, that I have heard Yvette.
For the flowers fade before her; see, the light
Dies out of that poor cheek, and leaves it white;
She sings of life, and mirth, and all that moves
Man's fancy in the carnival of loves;
And a chill shiver takes me as she sings
The pity of unpitied human things.
 —Arthur Symons

Plate 15

Yvette Guilbert (right)

1895, ceramic plate, 51 × 28 cm (20 × 11 in), Albi, Musée Toulouse-Lautrec

At the bottom Guilbert has written: 'Petit monstre! Vous avez fait une horreur!'

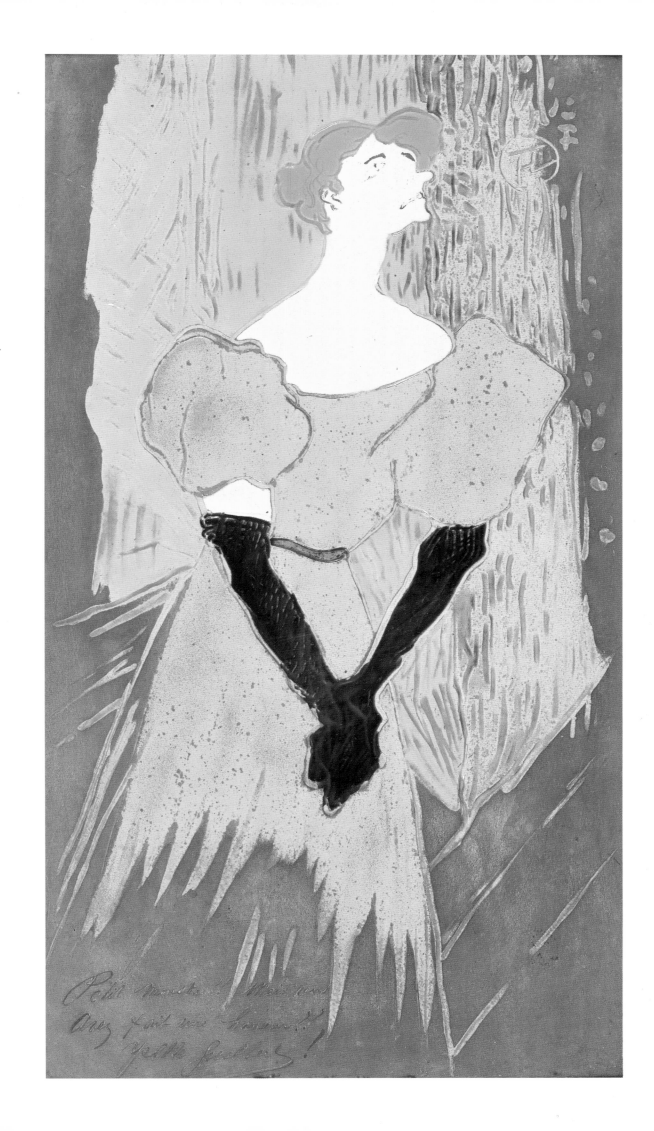

Plate 16

La Goulue and Valentin-le-Désossé

*1889–90, oil on canvas, 61 × 50 cm (24 × 19¾ in),
Winterthur, Reinhart Collection*

For ten years La Goulue (Louise Weber) remained a fixture of the nightlife of Montmartre. She had danced first as one of the crowd at the Moulin de la Galette, then, as her acrobatic prowess, riotous sense of fun and ignorance of any prudery or sense of shame became apparent, she was promoted by the management of the Elysée-Montmartre and finally the Moulin Rouge, to become the most famous exponent of the *quadrille naturaliste* of all time. Partnered by the tall, silent Valentin, his rubbery limbs and her frenetic energy created a chemistry which entranced the spectators and inspired some of Lautrec's most vivid dance studies. His relationship with La Goulue was complicated; like Lautrec she was a heavy drinker, and although she had male protectors, and even attracted the attention of the Prince of Wales, the future Edward VII of England, on a celebrated visit to the Moulin Rouge—when she removed his hat with a swift kick of her toe and demanded a bottle of champagne—Louise Weber preferred her own sex. She was often in the company of a girl known as La Môme Fromage, who when La Goulue denied that she was a lesbian retorted with some graphic details of their relationship in private that quickly made the rounds of Paris gossips. Lautrec would have found this quite attractive as he had a particular fascination for the love between two women. When La Goulue left the Moulin Rouge in 1895 she went to perform in a circus booth at the Foire du Trône, and asked Lautrec to paint two huge panels to decorate the front of the building. These canvases are now in the Musée d'Orsay and the central part of the one showing La Goulue's performance in Montmartre is based on this study. As for Valentin, he returned only once to the old dance-hall, for the farewell evening in 1902, before it was converted into a theatre. No one seems to know what became of him, he gave no interviews, and even his date of death is disputed. Some say he died in 1906, yet José Shercliff claimed he came to the 'Toulouse-Lautrec Ball' organized by Paul Colin in 1935. See pages 14 and 15.

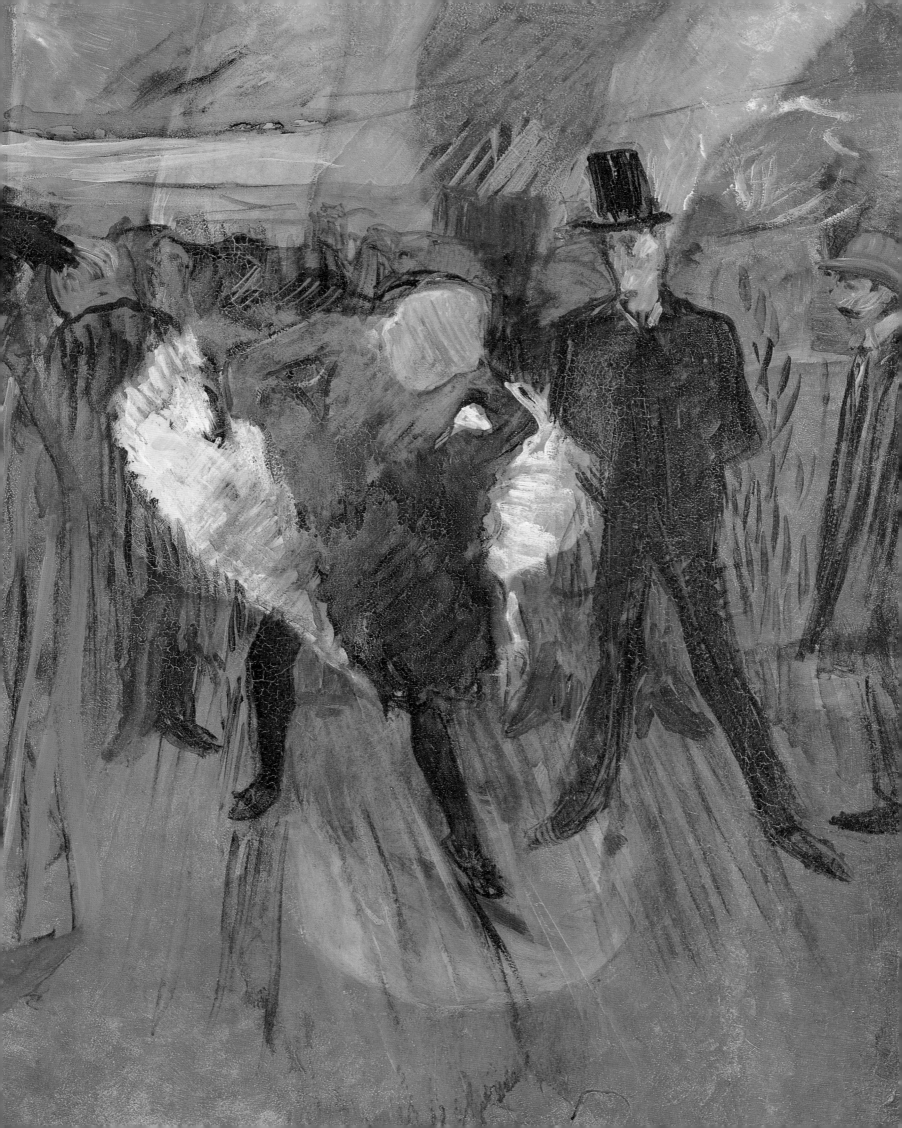

Plate 17

In the Circus Fernando: the Ringmaster

1888, oil on canvas, 100 × 161 cm (39½ × 62 in), The Art Institute of Chicago

The circus attracted Lautrec almost as much as the dance-halls and café-concerts, but unlike the other places of entertainment it was much less the audience and much more the performers that he drew and painted. In most of his pictures the seats are largely empty, drawing attention to the acts in the ring, and making one suspect that he chose to frequent the rehearsals or out-of-season performances rather than the popular hours. His early training as a painter of equestrian and other sporting subjects is evident in this large-scale work, as well as in the great series of drawings that he made from memory whilst undergoing the cure for alcohol-dependence in the penultimate year of his life. The Cirque Fernando was on the Boulevard Rochechouart, but in 1894 it was transformed into a theatre. The future impresario of the Moulin Rouge, Joseph Oller, had opened the Nouveau Cirque in 1886, and it was there that Lautrec drew the clowns Footit et Chocolat (page 62). Though they later only had singers, dancers and acrobats, the music-halls of Paris in the 19th century also featured many performing animals on their bills. The Folies Bergère even had a special area constructed backstage to fit in the lions' cage, and made room for a troupe of elephants. In this bold composition, despite the prominence of the equestrian, the silhouetted flapping tails of ringmaster's coat and the expanse of pale floor, there is a tremendous amount of detail, from the two clowns, cut off by the frame, the spectators and the contrasting expressions on the two circus artists' faces. André Lhote compared Lautrec's circus studies with the *Caprices* of Goya or the drawings of Daumier.

Before the drum-roll: the moment of suspense (Photo: Sirot)

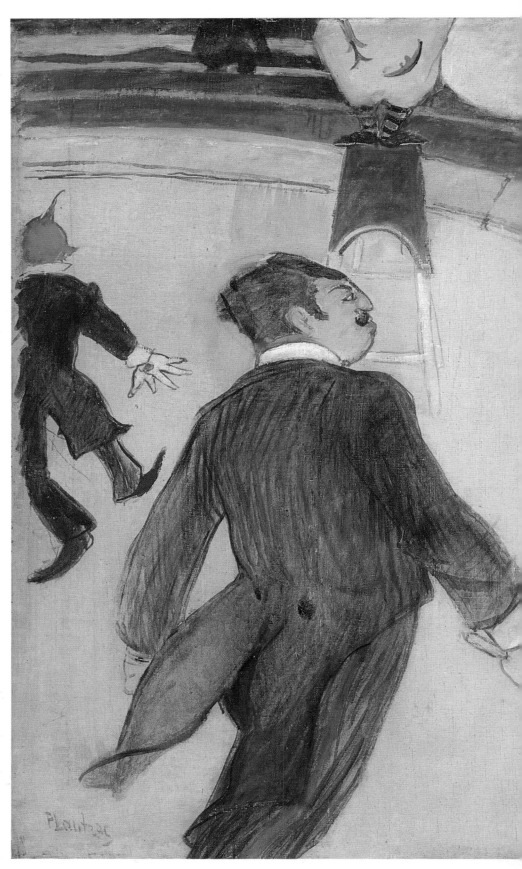

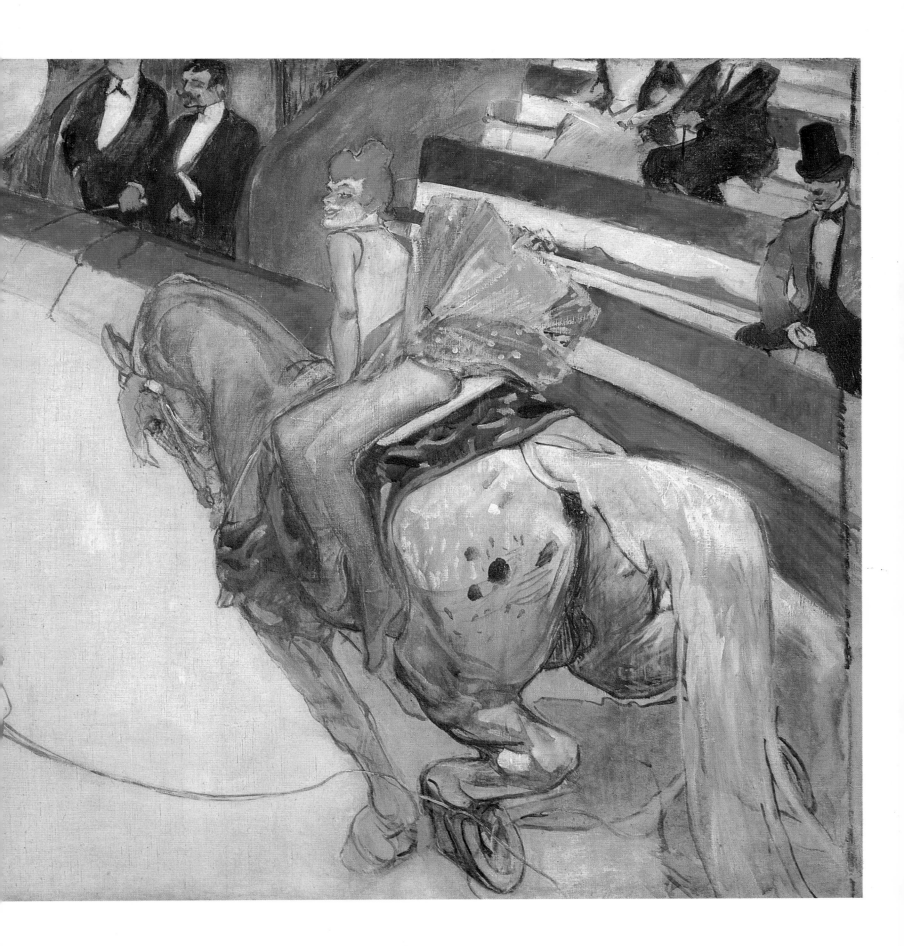

Plate 18

Caudieux

1893, monochrome ink, heightened by red, on paper
114 × 88 cm (45 × 34¾ in), Albi, Musée Toulouse-Lautrec

Paris Qui Chante cost 30 centimes and published half a dozen songs a week

One of several male stars of the café-concerts whom Lautrec drew, Caudieux is remembered today only because he was lucky enough to commission a poster for which this painting is the study. The traditional white tie and tails of the music-hall comic, his elaborate make-up that does nothing to hide the prematurely obese and ageing face, cruelly caught by the footlights, suggest that he was something like the great Mayol, whose quiff and prancing manner and high baritone so entranced Marcel Proust. The weekly journal *Paris Qui Chante* published the words and music of the latest popular songs. It was edited by the singer Polin, who was one of Lautrec's subjects for his series of lithographs of music-hall personalities in 1896. Romantic, slightly suggestive ballads like *Viens, Poupoule, Cousine* and *Si tu veux, Marguerite*, were quite different from the sagas of prison, the scaffold and prostitution sung by Aristide Bruant, or the cruel poems favoured by Yvette Guilbert. When Proust went to hear Mayol, he wrote to Reynaldo Hahn, 'Mayol entertains me so much, what I adore about him is that he dances as he sings, his whole body follows the rhythm. If I could, I would get him to come and sing *Viens Poupoule* and *Un Ange du pavé*'. Hahn for his own part wrote at length about the great artists of the café-concert: 'In France, singers of popular song have always strived for variety of expression, of diction, of vocal effects . . . This succession of joyous, tender or trivial airs sets my imagination whirling and puts me into a curiously receptive frame of mind'. The difference between a café-concert and a cabaret was at first simply that at the latter the entertainment was free—the players and singers were merely there to amuse the customers while they drank. At the former one went especially for the music and paid an entrance fee, being under no particular obligation to eat or drink.

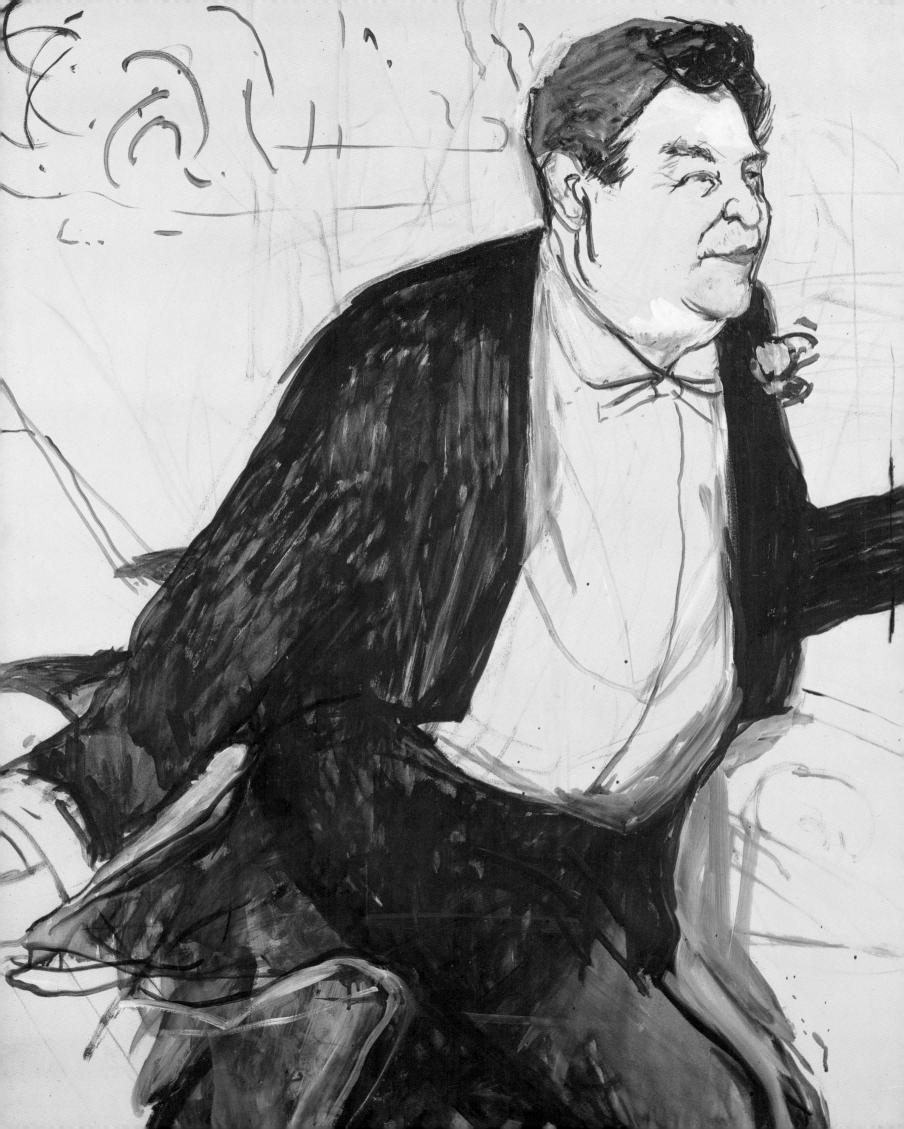

Plate 19

At the Café La Mie

*1891, watercolour and gouache on board, 53 × 68 cm
(21 × 26¾ in), Boston, The Museum of Fine Arts*

The rather depressed-looking couple, somewhat bored by their simple repast, are in complete contrast with the romantic devotion of Lautrec's model Marie-Léonie Yahne and her companion Louis Gauthier, embracing over the oysters and champagne. Lautrec himself put food and drink high on the list of priorities and was an accomplished cook, as well as mixer of cocktails. Jane Avril recalled the ordeal of the cocktail shaker; his guests had to endure cocktails as a pre-dinner aperitif, and Lautrec would put on his apron and start to pour, apparently at random, many different liqueurs into the bowl. Marcelle Lender reported that he enjoyed eating sour pickled herrings, and in a letter written to Jacques Bizet, the composer's son, in 1899, he sent an elaborate shopping list for different sorts of fish, including eels, hake and lobster, that with garlic, pepper and oil he was planning to make into a rich stew. Perhaps the most touching instance of Lautrec's eating habits comes in the memoirs of Misia Natanson, who recalled that Lautrec invited her and her husband, Thadée, to a special luncheon crawl. They ate each course at a different restaurant, with special wines that Lautrec had had delivered from his family's cellar. Then, as a surprise, he walked them round to the apartment of his friend, the bassoonist, Desiré Dihau. The three friends climbed the stairs, and entering the musician's flat, Lautrec pointed to a canvas on the wall. It was Degas's portrait of Dihau with the other orchestral players at l'Opéra, and he said, 'There you are—that's your dessert.'

Louis Gauthier and Marie-Léonie Yahne demonstrate the art of the *souper intime*

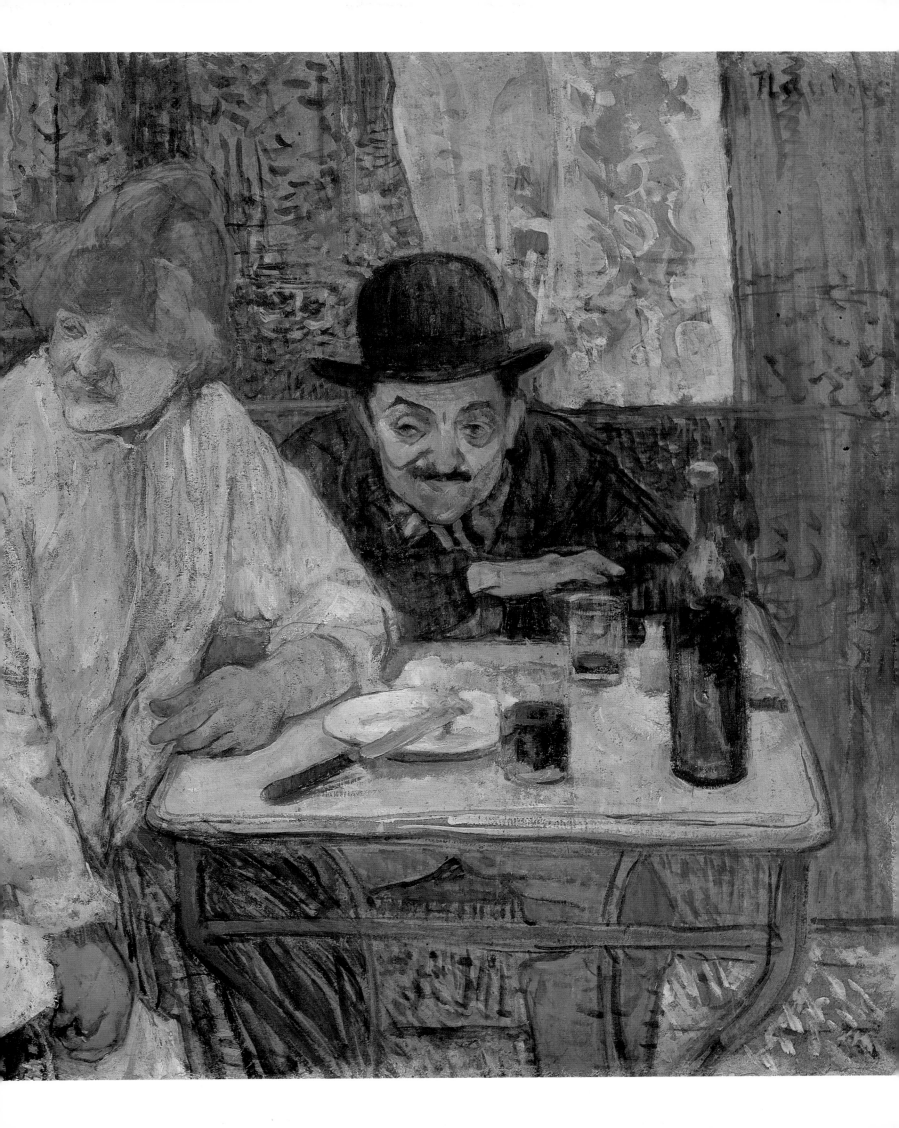

Plate 20　　　　　　**Chocolat Dancing**

1896, chinese ink and blue chalk heightened with white on paper, 65 × 50 cm (25½ × 19¾ in), Albi, Musée Toulouse-Lautrec

Le Cake-Walk at the Nouveau
Cirque: ragtime hits Paris

This drawing of the black acrobat and dancer, who took the stage-name Chocolat, seems to foreshadow the many black performers who made their mark in Paris in the 1920s. Although Chocolat was not American (he came from Bilbao), he used to include a banjo-playing routine in his act: he was most famous as the partner of the clown Footit, and even today there are elderly Parisians who remember being taken to the Nouveau Cirque to see 'Footit et Chocolat'. Lautrec drew Chocolat on a number of occasions, but this bold study, which also served for a lithograph, is his major appearance in Lautrec's oeuvre. The sense of movement, the grace of the dancing gesture, is offset by the unsentimental caricature of Chocolat's profile. It is interesting to compare it with the photograph of two dancers at the same circus in the cake-walk. The girl is obviously a boy in drag. This picture dates from the time of the first wave of Afro-American music being popular in Paris. Although a quartet of black musicians from Virginia was reported to have played at the Palais Royal as early as 1844, it was in the 1900s that the cake-walk, ragtime and the appearances of Williams and Walker in *In Dahomey* launched the trend that would reach its apotheosis with *La Revue Nègre* in 1925, and night-spots such as Chez Florence, Bricktop's Chez Joséphine and Le Bal Nègre. The Irish-American Bar, presided over by Achille, was in the rue Royale, and it was here, when the performance at the circus was over, that Lautrec encountered Chocolat. Just as American music was becoming fashionable, so too was 'le cocktail'.

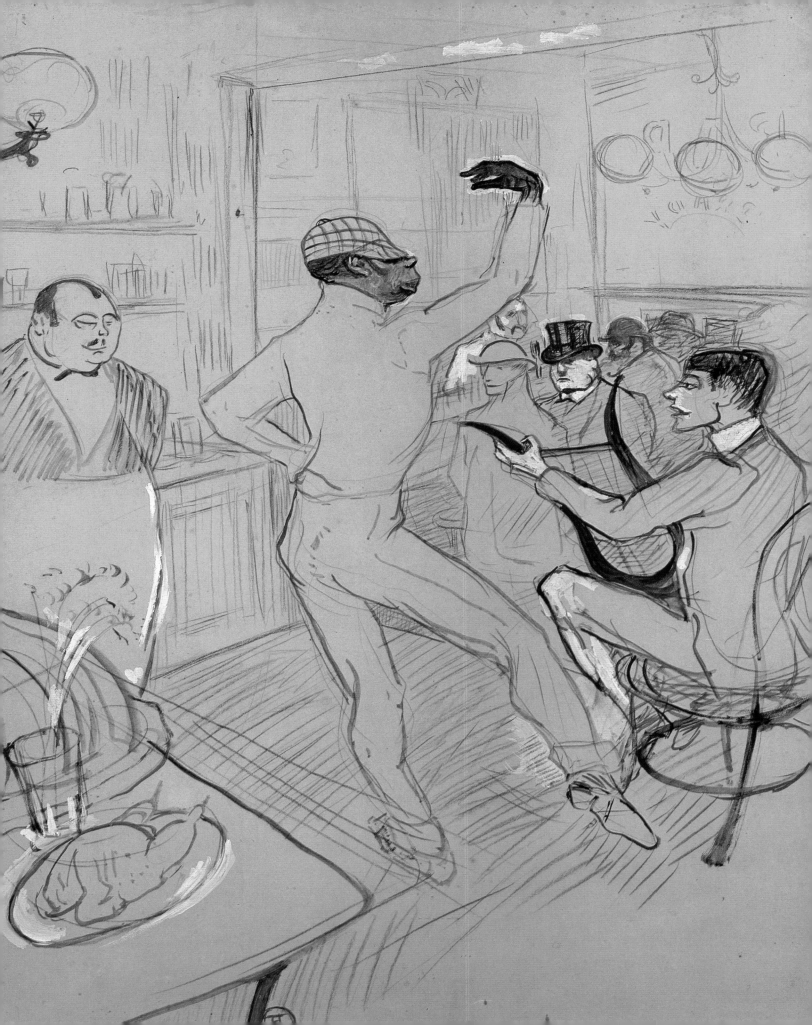

Plate 21 A Corner of the Moulin de la Galette

1892, oil on cardboard on wood, 100 × 89 cm (39½ × 35 in), Washington, D.C., National Gallery of Art

Jeanne Bloch: cross-dressing
at its most intense

A picture of this popular dance-hall had been captured in a painting with great success by Renoir in 1876. His sunlit, pink, blue and gold dancers bear no resemblance to the decadent-looking spectators that Lautrec has caught in this painting or his rough-seeming crowd in the earlier dance scene (pages 6–7). The woman with close-cropped hair and mannish-looking coat is one of the frequent allusions that Lautrec makes in his paintings to his fascination with Lesbianism and cross-dressing. This was a theme that was taken up, not always so seriously, by satirists and song-writers. The fashion for bicycling had introduced the idea of ladies wearing a form of trouser, the baggy bloomers, and prompted one of the most famous café-concert songs of the time, *Frou-Frou* by Henri Chatau, and such grotesque turns as the one shown here by the singer Jeanne Bloch. Although she does not figure in any of Lautrec's lithographs or posters, Bloch who was known as 'Tanagradouble', was a regular at Le Chat Noir, and first appeared in a starring spot at the café-concert *Scala* in 1886. The fashion, verging on obsessiveness, for music-hall performers to appear in costumes of the opposite sex in England and in France, must have grown out of the refusal of mid-19th century society to discuss sex openly, no matter what we may think today when reading the works of Zola, the Goncourts or Baudelaire. For the ordinary theatregoer the opportunity to make sexual embarrassment a laughing matter was of the utmost urgency.

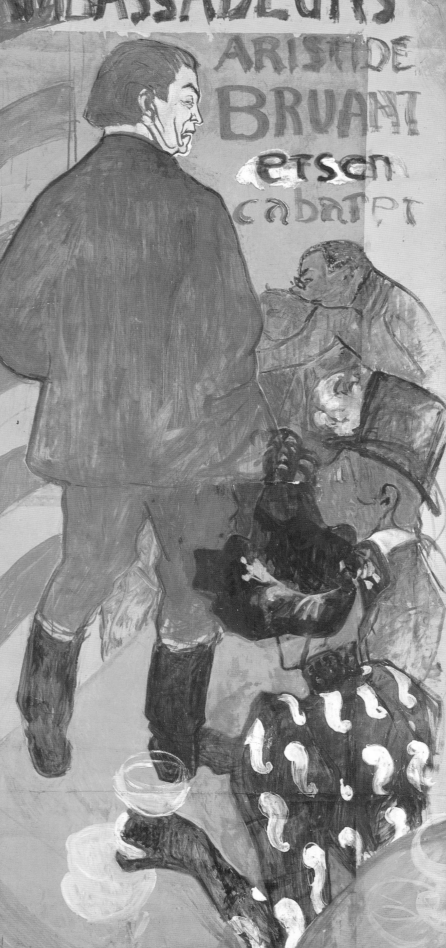

Plate 23

In the Salon

1893, pastel, gouache and pencil on cardboard, 53 × 79·7 cm (21 × 31½ in), New York, Solomon R. Guggenheim Museum

Nearly all Lautrec's paintings of the women in the various brothels in which he stayed and painted, show them among themselves, either as here, at the hour at which they are expecting clients to arrive, or playing cards, making-up, combing their hair, or resting. The absence of male figures, and the repose of the models, give to these scenes an air of calmness that removes the other element that must have been present: expectancy. The tension that the client is usually said to feel when confronted by the spectacle of a choice of available girls is unobserved and, if anything, there is merely a feeling of boredom. The brothel in the rue des Moulins was frequented by the rich and famous. These houses were also used for assignations; if one man wished to introduce another to one of his conquests, he might arrange to bring her to such a venue. In her published recollections Jane Avril recounted how she had been enticed to one by a young man whom she had met at the Moulin Rouge. Upon arrival at the establishment and being introduced to the friend he had insisted wished to make her acquaintance, she realised she had been led to a brothel and that she was conversing with the Madame and with one of the most notorious sadists in Paris. Her acrobatic dancing had given her good practice to beat a hasty retreat down the stairs and the language she used, she claimed, seemed to shock even the hostess. In Paris, in the 19th century, the majority of girls who found their way into prostitution were either orphans or destitute. The legend of the courtesan who took up the profession out of a spirit of gallantry and because it offered adventure was a male-invented scenario, perpetrated by such romantic tales as *La dame aux camélias*: the reality was harsher but less extreme.

Emilienne d'Alençon: most soulful of the famous 1900s courtesans

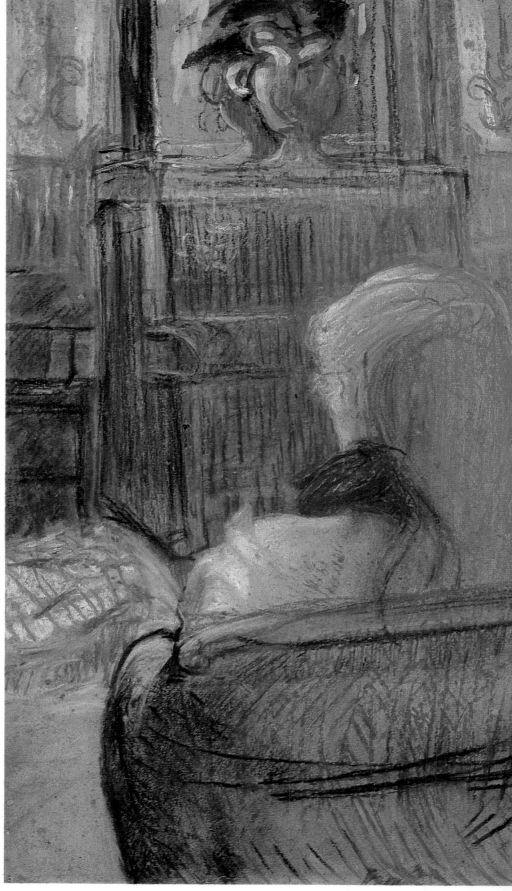

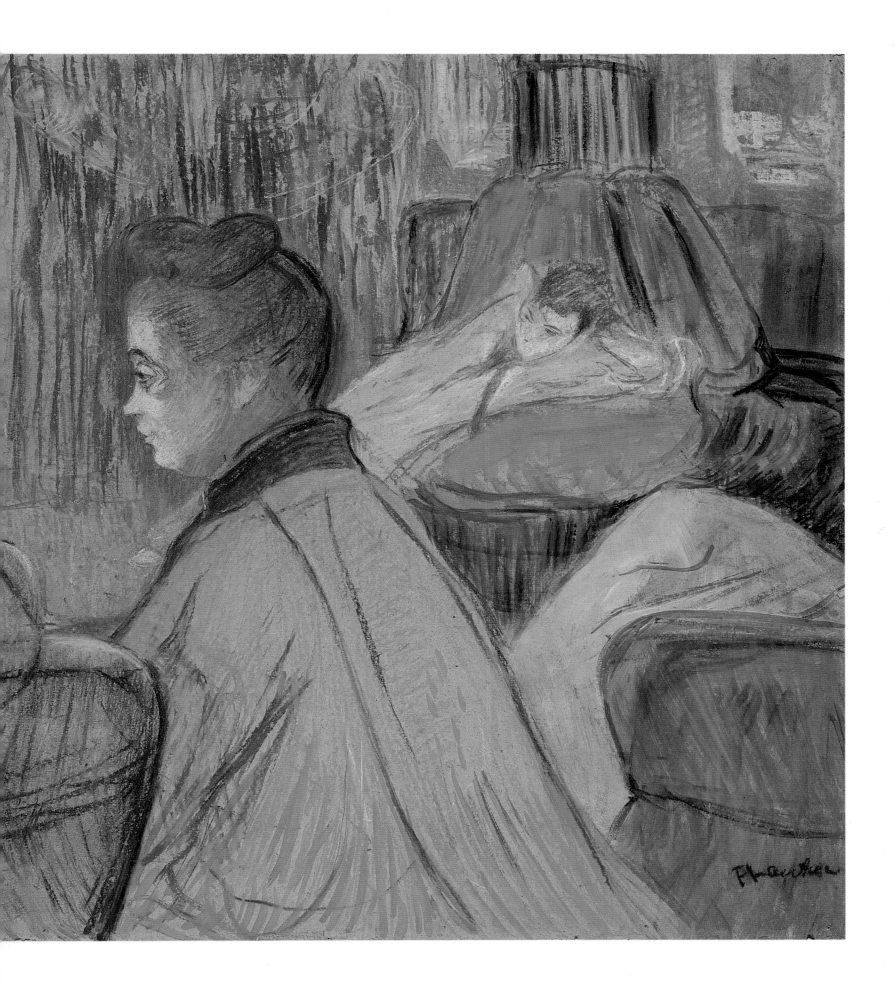

Plate 24 # Rue des Moulins

1894, oil on cardboard on wood, 83.5 × 61.5 cm (33 × 24 in), Washington, D.C., National Gallery of Art

The hard-working staff of the rue des Moulins

The fear of venereal disease, which was frequently fatal for client and prostitute, seems to have had little effect upon the urban sex lives of 19th-century Frenchmen. In this study of the women queuing up for the doctor's inspection, perhaps the most provocative of all Lautrec's brothel pictures, the look of resignation on the older woman's face, the defiance on the younger one's countenance, are a reminder that, despite moves on the part of legislators no attempt was ever made to restrict the behaviour of the male clients or to suggest that they should undergo tests or take precautions. Earlier in the century, the public health specialist Alexandre Parent-Duchâtelet had produced a two volume study, *De la prostitution dans la ville de Paris*, in which he had suggested that it would be a good idea to round up the streetwalkers and seclude them. He produced a survey of 5,183 Paris prostitutes, who operated on various levels, showing the determining causes that had led them into this profession. Parent's main theme was the spread of disease and he was an advocate of *maisons de tolérance*, brothels that were permitted by the authorities so that a check could be kept on them. He was adamant against what he felt were the most dangerous—*les femmes galantes*—outwardly respectable or well-to-do women, who operated in cafés, theatres and dance-halls: 'More than any others, they spread diseases and early infirmities,' he wrote; 'they destroy one's fortune as well as one's health, and can be considered the most dangerous people in society.' It has been asserted that it was from one of the girls who frequented the Elysée-Montmartre, known as Rosa la Rouge, that Lautrec contracted venereal disease himself. One of his drawings of her was used to illustrate Bruant's song, *A Montrouge*:

'C'est Rosa ... j'sais pas d'où qu'a vient,
Alle a l'poil roux, eun' têt' de chien ...
Quand a'passe on dit v'là la Rouge,
A Montrouge.

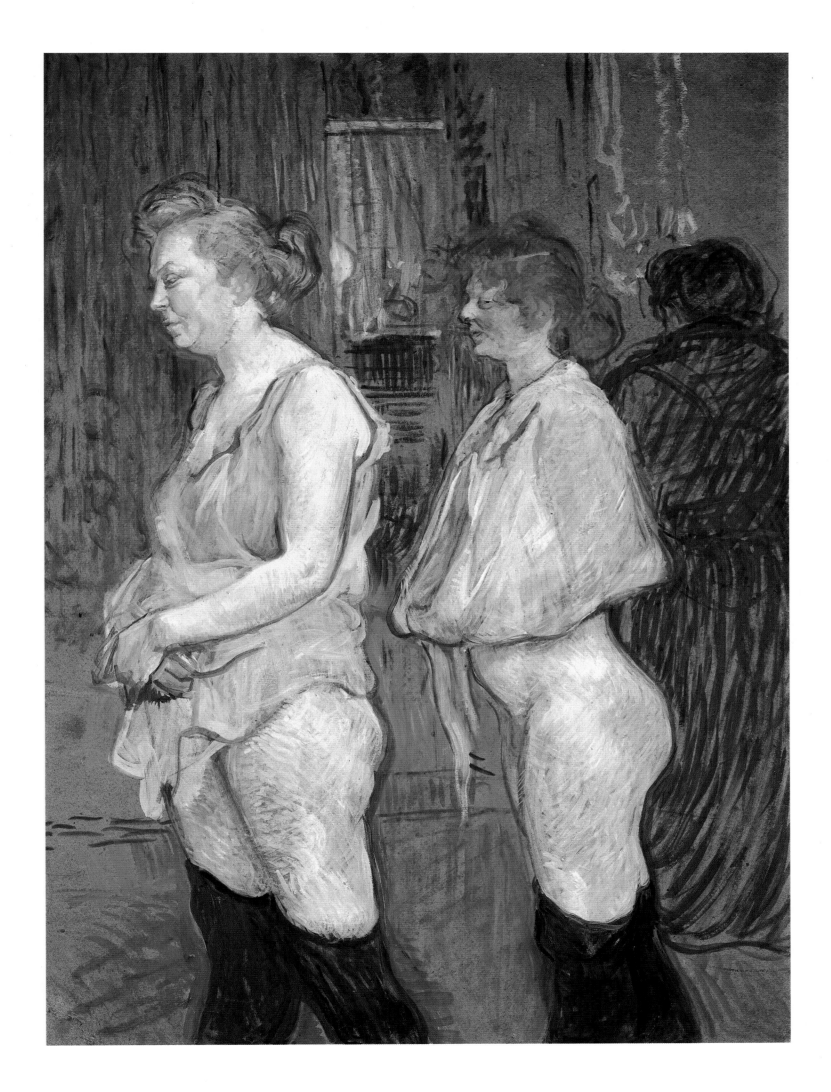

Plate 25 **Detail from Women in a Brothel**

1895, oil on canvas, 58 × 79 (22¾ × 31 in),
Budapest, Museum of Fine Arts

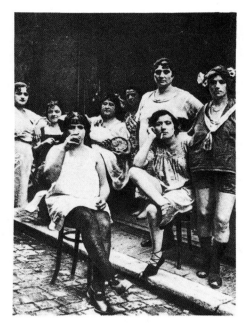

Waiting: a sense of boredom,
or hopelessness

This cosy scene, which if one did not know it was the dining-room of a brothel, might be mistaken for the canteen of some respectable workshop or dressmaking establishment. In their flights of erotic fantasy about the nature of prostitution, Baudelaire, Flaubert and all the other writers of the mid-19th century who addressed the subject so volubly, seldom managed to convey the matter-of-fact ordinariness that seems to have amused Lautrec. Similarly, the songs that Bruant, Guilbert and the other realistic singers of the time sang depicting the underworld, often veered towards sinister melodrama quite out of place in the businesslike houses in which Lautrec painted. The songs the girls would play and sing would not have concerned drink, drugs and the guillotine, as on the café-concert platform. More likely it would have been the sentimental ballads of Paul Delmet or the sad, slow waltzes of Waldteufel that wafted along the corridors and down the staircases of the houses in the rue d'Amboise and rue des Moulins. After the Second World War, a new law was enforced in Paris which led to the closure of most of the large-scale brothels. The contents of the establishment in the rue des Moulins were auctioned, and one item, an elaborate copper inlaid bathtub was put on display in an antique dealer's window. According to Henri Perruchot in his biography of Lautrec, one day two very old ladies came into the shop to look at it. Did they wish to know the price, the dealer enquired? They answered no, they were just looking, for old times' sake, it brought back so many memories. 'Perhaps,' wrote Perruchot, 'locked in their hearts, they still preserved the memory of a little crippled man of genius who had loved them better than anyone else.' Fanciful words, but not inappropriate when one compares Lautrec's work in this field with that of his contemporaries.

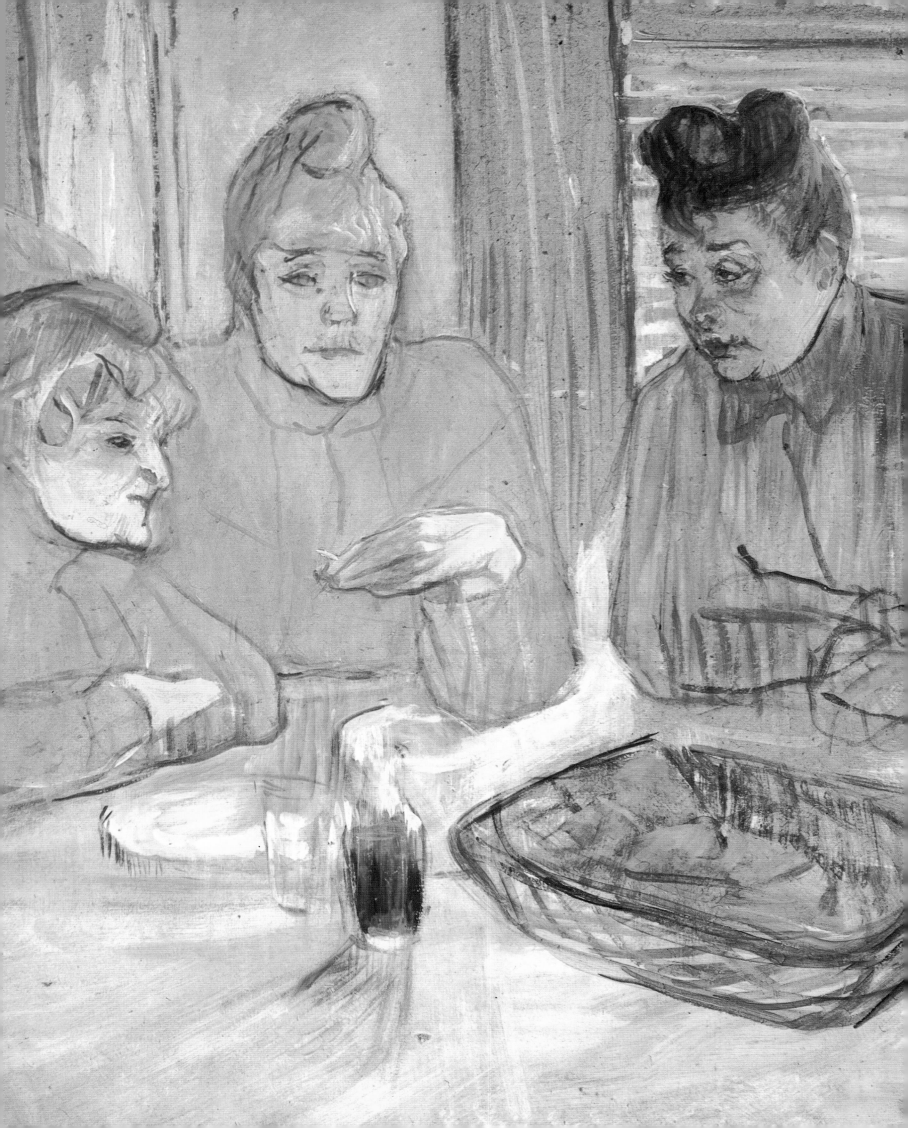

Plate 26 **Detail from The Two Friends**

1895, oil on card, 58 × 79 cm (22¾ × 31 in), Zurich, the Foundation E. G. Buhrle Collection

Lesbianism for fun: at the
Olympia music-hall *c.* 1899

The fascination with the love of one woman for another that is expressed by Lautrec in many of his brothel studies, as well as in some of his observations of dancers and members of the public in the theatres and music-halls, is at its most tender in this painting. Throughout the 19th century in France there had been a tradition of approaching Sapphism in an uninhibited way in nude studies, for instance in the coyly erotic work of such masters of academic boudoir painting as Bouguereau, Garnier and even Lautrec's teacher, Bonnat. The realism of the approach used by Lautrec here would have made a scandal had the painting been exhibited. The enthusiastic attitude of so many men towards Lesbianism does not generally seem to be mirrored in a sensual way in women's reactions to male homosexuality. Colette, in her study of the subject published as *Ces plaisirs*, wrote 'The seduction emanating from a person of uncertain or dissimulated sex is powerful. Those who have never experienced it liken it to the banal attraction of the love that evicts the male element. This is gross misconception. Anxious and veiled, never exposed to the light of day, the androgynous creature wanders, wonders, and implores in a whisper.' In Montmartre, at the turn of the century, there was at least one basement cabaret that catered exclusively to lesbians; there the ballads of the extraordinary Augusta Holmès were sung by a contralto while the women found a sort of refuge from the whirl of the nightlife at ground level, with its blatant insistence upon the glorification of promiscuity.

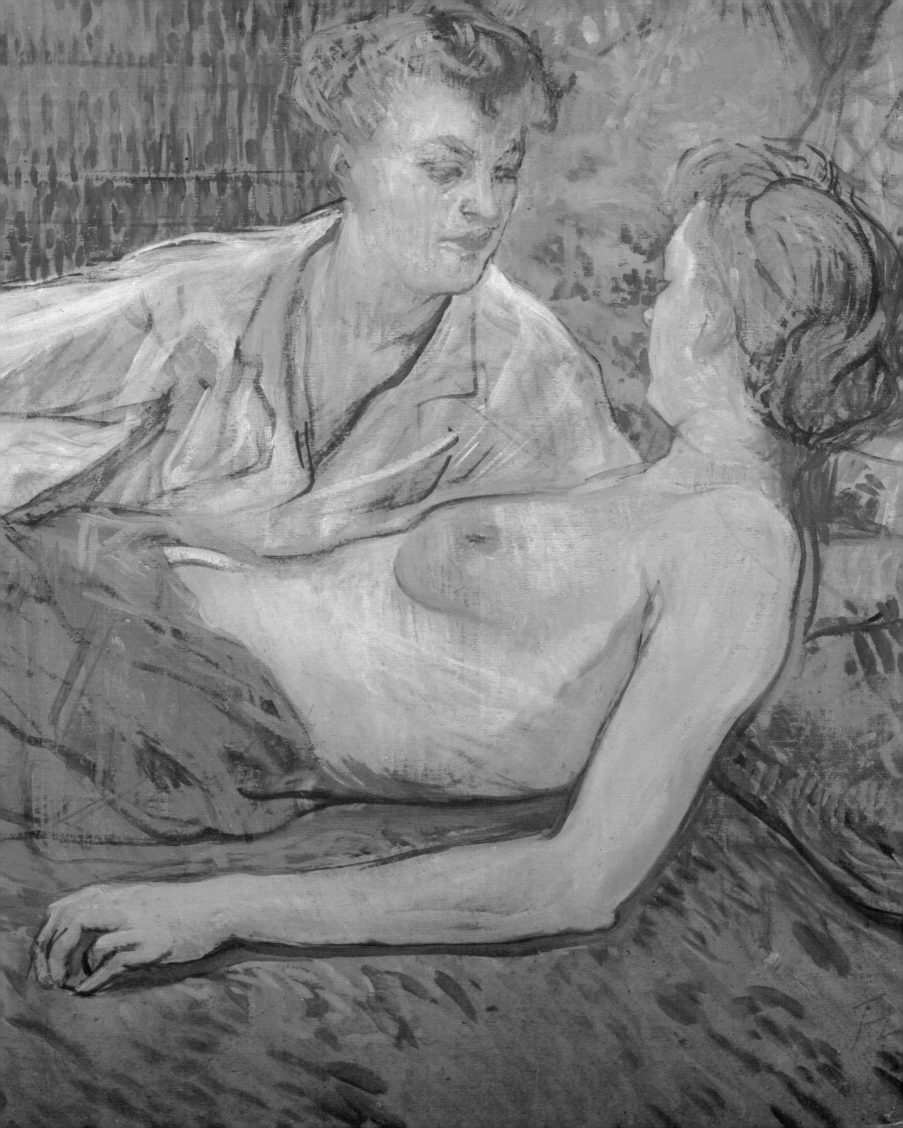

Plate 27 # The Brothel Laundry Man

1896, oil on card, 58 × 46 cm (22¾ × 18 in), Albi, Musée Toulouse-Lautrec

The supposed bed of Marie Antoinette

In this painting Lautrec has addressed not only an unusual subject but he suggests layers of complicated relations. The laundryman, whose eyes have an unusually intense stare, was said to have been consumptive. The rather prim stance of the woman about to check off the list of items lends a bourgeois atmosphere to what is otherwise an essentially scandalous subject. Obviously, the laundry was one of the most essential tools of the prostitutes' trade. The provision of clean towels, sheets and other napery raised such establishments from the level of mere whore-house into luxury hotels. Then, the elaborate costumes which many of the inmates were said to wear, no matter how flimsy, also added to the allure and raised the price. In the corridor the visitor might meet a nun, a white-veiled bride, or any number of exotically costumed participants. One commentator remembered that so great was the curiosity aroused by these goings-on that a number of respectable ladies eventually found their way into the house as voyeurs, and Lautrec was heard to say, 'The greatest whores are the ones who come as spectators.' The other aspect of interest where the question of the laundryman arises, is the trade that was carried on according to the surveys, made in Paris by the Bureau of Morals. These revealed that there was a certain procuress who posed as the manageress of a laundry. She employed a team of young women to deliver the sheets to the clients she had selected, thus avoiding any suspicion by the neighbours.

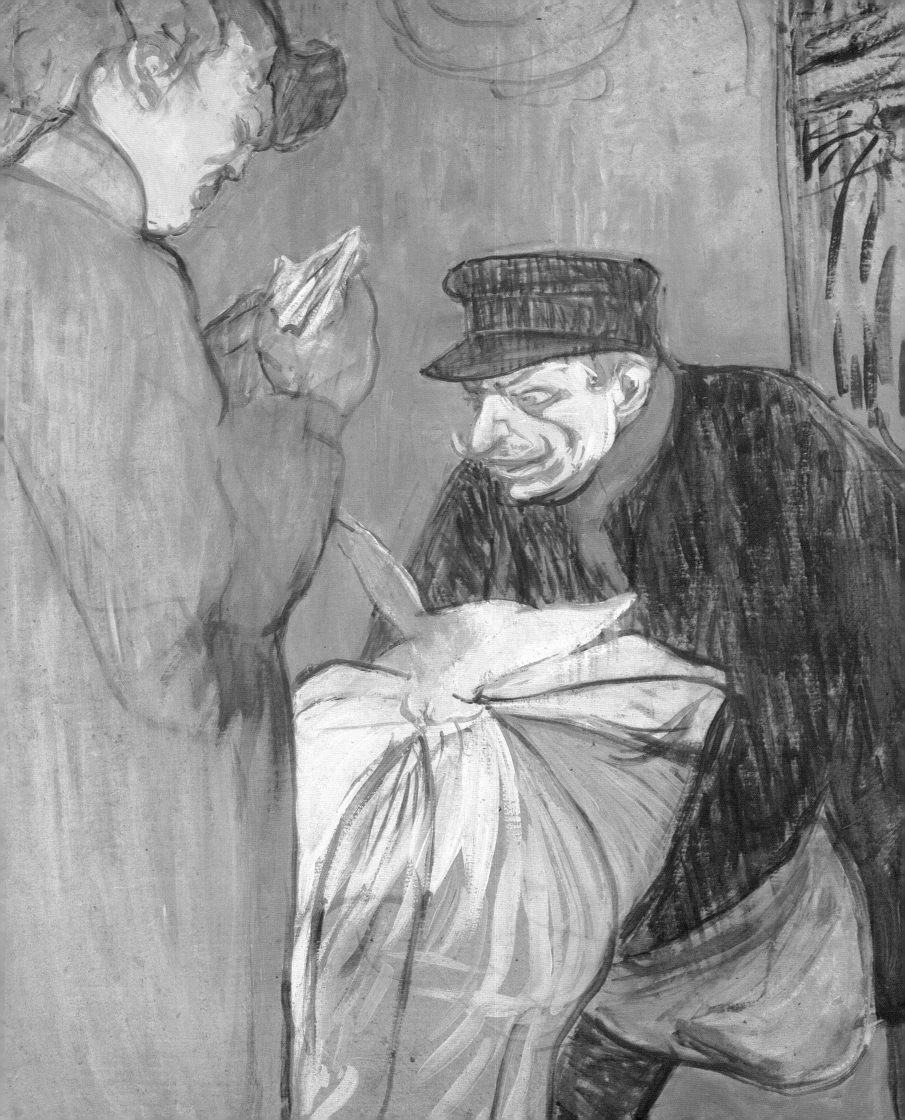

Plate 28

Women Ironing

Oil on canvas, 54 × 81 cm (21¼ × 32 in), Wuppertal, Von der Heydt Museum

One of the paintings that shows the other side of the nightlife of Paris, neither sensual nor entertaining, but the labour behind all the elegance on the surface. A further example of Lautrec's work in which the influence and subject-matter refer to Degas, this also poses an interesting question as to why so many artists have been drawn to depict laundresses. One simple answer is that, given the heavy nature of the work, it was open only to those who were physically fit and therefore robust models. There is something more to it, however, and of course La Goulue herself had begun her career among the flat irons and starch. In the 1890s the character of a *blanchisseuse* was given its final certificate of authority by Sardou in his vehicle for Réjane, *Madame Sans Gêne*. Lautrec made at least two studies of Réjane in this part, a laundress–camp follower, whose clients include the young Bonaparte and who, in the final act, having raised herself to the rank of a Duchess presents an unpaid account to the Emperor. This play went round the world and was twice adapted for the musical stage as a light opera, first by Ivan Caryll as *The Duchess of Dantzig*, then by Giordano as *Madame Sans Gêne*. Réjane herself was second only to Bernhardt in the estimation of contemporary critics, although she excelled in high comedy and melodrama, rather than the classics. After the role of the laundress, her most famous parts were in Simon and Berton's *Zaza* and in one of the earliest French productions of Ibsen's *A Doll's House*. Of this performance Adrien Laroque wrote, 'With what art, what absolutely perfect nuances she plays the role, we laugh and suffer with her ... it is an unparalleled interpretation.'

Réjane (1857–1920) as the laundress in *Madame Sans Gêne*

Further Reading

ADRIANI, G. *Toulouse-Lautrec*, 1987

CARADEC, F. and WEILL, A. *Le Café-Concert*, Paris, 1980
 Catalogue Musée Toulouse-Lautrec, Albi, 1985

COLETTE *L'Envers du Music Hall*, Paris, 1913

COOPER, D. *Toulouse-Lautrec*, New York & London, 1983

GUILBERT, Y. *Autres Temps, Autres Chants*, Paris, 1946

GUILBERT, Y. *La Chanson de Ma Vie*, Paris, 1927

HUISMANN, P. and DORTU, M. G. *Lautrec by Lautrec*, London and
 New York, 1973

JOURDAIN, F. and ADHÉMAR, J. *Toulouse-Lautrec*, Paris, 1952

LESLIE, P. *A Hard Act to Follow*, London, 1979

OTIS SKINNER, C. *Elegant Wits and Grand Horizontals*, London
 1962

PERRUCHOT, H. *Toulouse-Lautrec*, London, 1960

PESSIS, J. and CRÉPINEAU, J. *Le Moulin Rouge*, Paris 1989

SCHIMMEL, H. D. (Editor) *The Letters of Henri de Toulouse-Lautrec*,
 Oxford, 1991.

SHERCLIFF, J. *Jane Avril of the Moulin Rouge*, London, 1952

SUGANA, G. M. *The Complete Paintings of Toulouse-Lautrec*,
London, 1973

WEILL, A. *100 Years of Posters of the Folies-Bergère and Music Halls
 of Paris*, New York, 1977

Acknowledgements

6–7 The Art Institute of Chicago, Mr and Mrs Lewis Larned Coburn Memorial Collection, 1933.458; 56–7 The Art Institute of Chicago, The Joseph Winterbotham Collection, 1925.523. © 1990 The Art Institute of Chicago, All Rights Reserved; Jacket (back), Bibliothèque Nationale; 8, 41, 43, 44–5, 49, 52, 53, 75, Giraudon; 26–7, Flammarion-Giraudon; 29 Bridgeman Art Library; 30–1, 38–9, 65, 71 Washington, D.C. National Gallery of Art, Chester Dale Collection; 33 The Metropolitan Museum of Art, Bequest of Miss Adelaide de Groot (1876–1967), 1967. (67.187.108) Photograph by Malcolm Varon; 59, 63, 67, 77 Lauros-Giraudon; 60–1 Boston, The Museum of Fine Arts, S.A. Denio Collection and General Income. © 1991 All Rights Reserved; 68–9 Solomon R. Guggenheim Museum, New York, Gift, Justin K. Thannhauser, 1978. Photo: Carmelo Gaudagno; 72 Interfoto-Munich-Giraudon.

Dawn 1896, coloured
lithograph, 61 × 80 cm
(24 × 31½ in)

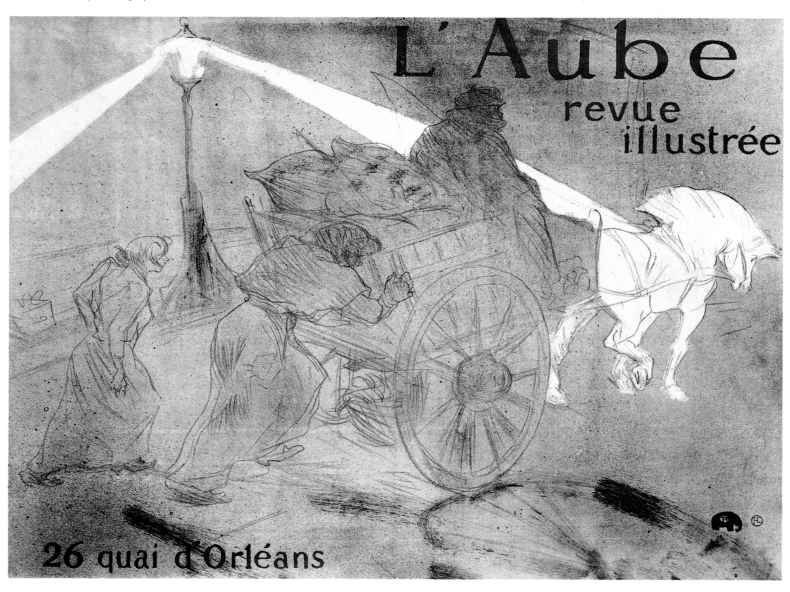

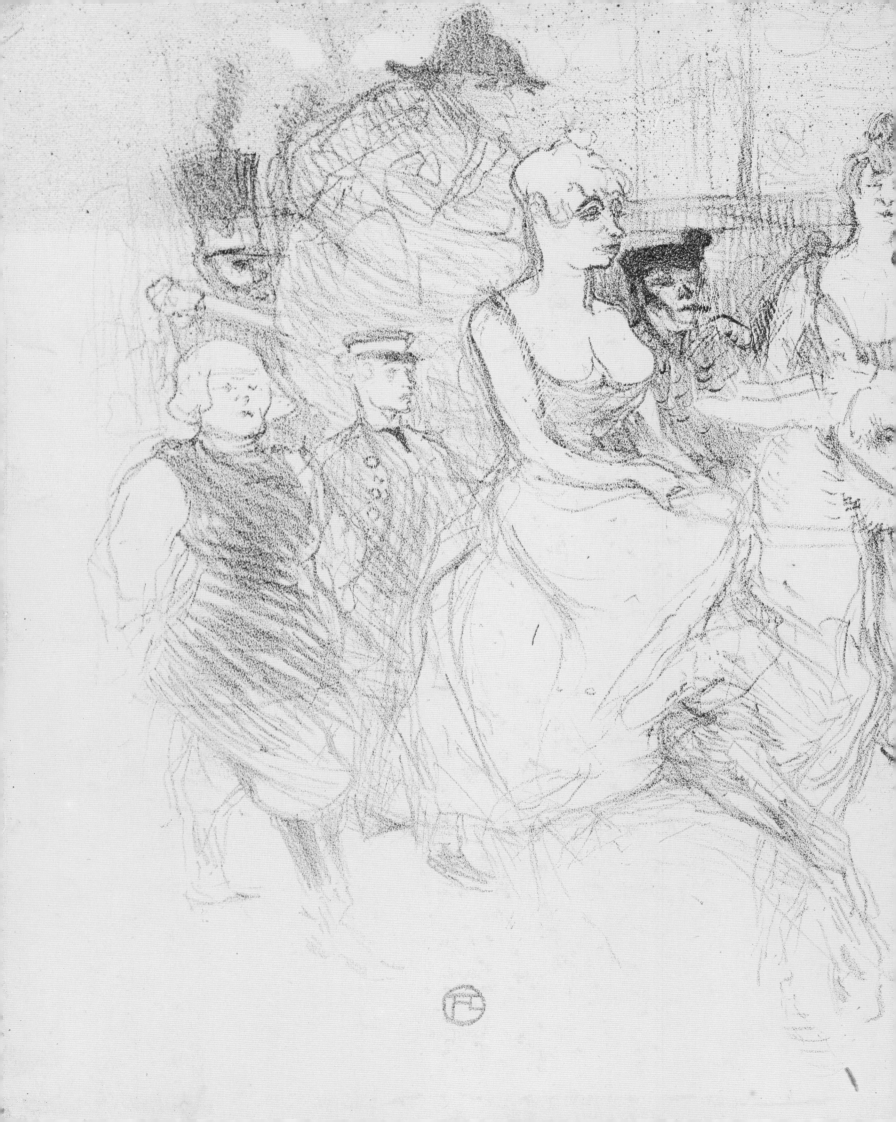